PHOTOGRAPHING
STILL LIFE

PHOTOGRAPHING
STILL LIFE

SETH JOEL

AMPHOTO

An Imprint of Watson-Guptill Publications/New York

Copyright © 1990 by Seth Joel

First published 1990 in New York by AMPHOTO,
an imprint of Watson-Guptill Publications,
a division of Billboard Publications, Inc.,
1515 Broadway, New York, NY 10036

Library of Congress Cataloging-in-Publication Data

Joel, Seth.
 Photographing still life / by Seth Joel.
 ISBN 0-8174-5475-6 : $29.95.—ISBN 0-8174-5476-4 (pbk.) : $22.50
 1. Still-life photography. I. Title.
TR683.J64 1989
778.9'35—dc20 89-18130
 CIP

Manufactured in Singapore

1 2 3 4 5 6 7 8 9 / 98 97 96 95 94 93 92 91 90

To Zoë and Tobias

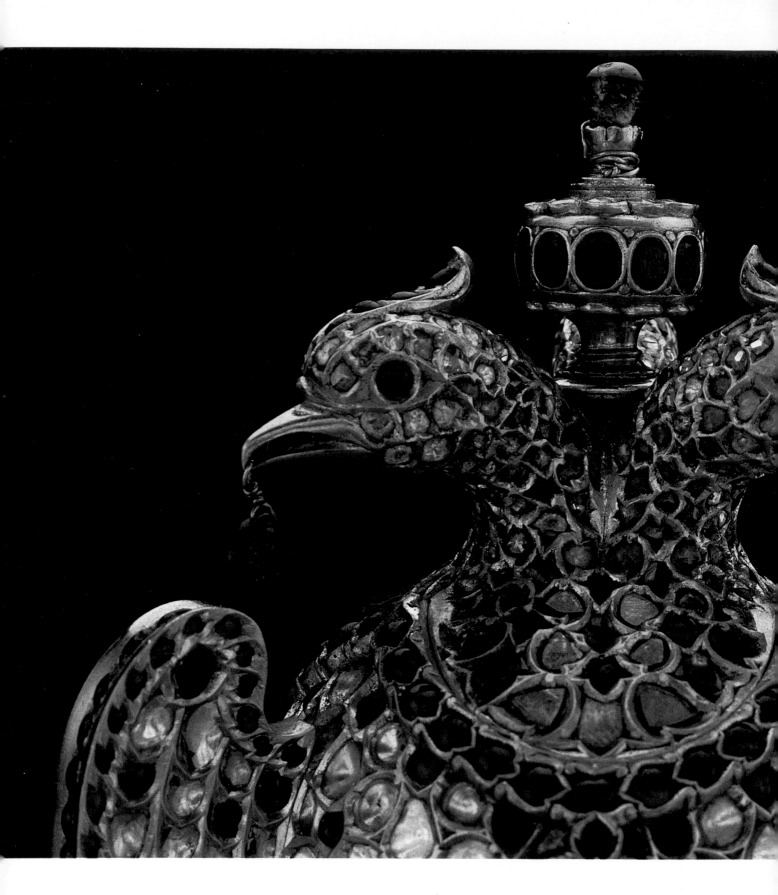

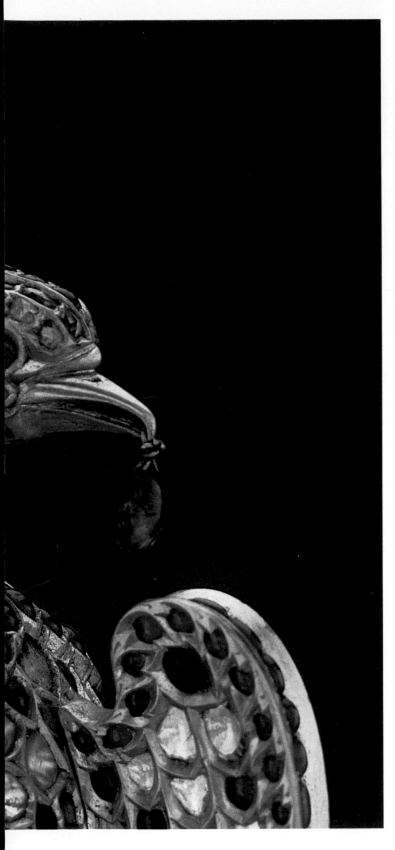

I would like to express my gratitude and thanks to several very talented people for their hard work and creative spirit in the production of this book. First, Susan Hall and Liz Harvey at Amphoto. Their belief in my work and their support helped make this book possible. Sincere thanks to Mark Carricker for designing and executing the lighting diagrams. Extra-special thanks to Shirley Joel and Lisa Folsom. Their creative input and professional knowledge inspired me throughout this project. My deep appreciation to Charlie Holland, my wife, for her loving support; and special thanks to Paul Wheeler for his work as my agent. Last of all, to Yale Joel, for all the years of his guidance, enthusiasm, and most important of all, the photographic EYE to make pictures.

CONTENTS

PREFACE

My father, Yale Joel, a former *Life* magazine photographer who was a member of the original staff of the magazine for more than 25 years, lived his craft. He always held court during dinner, discussing the day's Polaroid tests. Naturally, technical and creative information was exchanged. My father also often entertained us with many colorful stories about his assignments. I grew up looking at pictures. I was fascinated.

Later, because I had no formal education in photography or design, my father encouraged me to apprentice in the field. I became a freelance assistant and worked in primarily the corporate and editorial markets. After several different experiences with a number of professional photographers, I met Lee Boltin, a noted still-life photographer who specializes in art objects. By observing this perfectionist at work, I quickly discovered how exacting art photography is. No detail can be overlooked. My apprenticeship with Boltin also gave me the opportunity to see firsthand the dramatically different results of various lighting techniques. I learned to be meticulous about every element of a photograph; to leave nothing to chance; and to test, test, test. I became comfortable with and accustomed to working with large, cumbersome cameras. I also grew familiar with museum etiquette: what photographers can and cannot do, how to handle precious art objects and, perhaps equally important, how to deal with frequently temperamental and highly sensitive artists, curators, and book publishers.

By 1977, after working with Boltin for three years, I signed my first book contract. *Egyptian Treasures,* published by Harry N. Abrams, Inc., was shot on location at the Brooklyn Museum in New York City. This three-week assignment was soon followed by *Treasures of American Folk Art,* another Abrams title, which I shot completely in the studio. These two poster-size books laid the groundwork for my next project, titled *The Great Bronze Age of China.* Published and funded by New York City's Metropolitan Museum of Art, this book contains photographs of various locations in China.

Although this was considered a plum assignment, it was fraught with pitfalls and the hazards of the unknown. In 1979, China had not yet fully opened to the West, so arranging to shoot on location in the ancient Imperial City of Beijing as well as historical sites in the Chinese countryside proved to be difficult. While museum representatives negotiated, I spent two months doing research and preparing for the trip.

During this time, carpenters at the museum constructed eight huge, wooden crates with interior padding for transporting my equipment. Despite my precautions, getting through the airports was always a struggle. The equipment crates vanished after the stop in Tokyo, but miraculously reappeared two weeks later in Beijing. While waiting for my equipment to surface, I scouted shooting space in the private "concubine" quarters of the Imperial City and began to unpack and establish a "studio." Whether I was loading sheet film in a primitive bathroom or exchanging techniques with the Chinese photographers assigned to assist me, I moved toward my goal: photographing ancient— and revered—bronze artifacts. This demanding but ultimately rewarding assignment lasted 12 weeks.

After my return from China and the subsequent publication of the museum catalog, I found myself unexpectedly catapulted into the ranks of many well-known, established photographers. Cornell Capa, the founder and head of the International Center of Photography (ICP) in New York City, invited me to be a guest lecturer. There was interest

not only in the photographs themselves, but also in the methods I used to accomplish this work under primitive conditions. The invitation was especially gratifying to me because Capa is one of the preeminent leaders of the photographic world, and I know how exacting his standards are. The evening was also quite emotional for me because Capa is my father's best friend.

At about the same time, Bloomingdale's mounted a storewide event in its flagship New York City store to showcase Chinese products. Marketing representatives had seen the catalog from the Metropolitan Museum of Art and asked for color blowups of certain images. These were then mounted and hung up throughout the store. My photographs of Sian warriors ended up selling Ralph Lauren socks.

I continued to travel and cover special exhibitions and collections. Armand Hammer, the internationally known art collector, gave me the opportunity to perfect the technique of photographing paintings; I shot his entire collection of Impressionist and post-impressionist works. Later, my eye for classic, modern design was developed on a project for the Museum of Modern Art in New York City. Other assignments took me to the South Pacific for a book on Hawaiian artifacts and to India for a photographic exploration of that country's incredible palaces. *Treasures of the Maharajahs* was the result of this two-month-long trek and, except for my trip to China, was my most challenging on-location project.

My father's enthusiasm and passion for taking pictures introduced me to the demanding but rewarding field of photography and set a standard for my own career. It is this standard—and my love of photography—that I wish to convey here.

INTRODUCTION

Some photographers shy away from still life because they think that inanimate objects are dull or boring. Also, the large cameras often required can seem intimidating. If you are one of these photographers, I encourage you to experiment, using, perhaps, your own jewelry or an art object that you have access to. Once you become aware of the creative possibilities and familiar with both the equipment and techniques involved, you will realize that shooting a still life is not that restrictive or difficult.

Before you begin shooting, however, you should think about the critical characteristics of a still-life photograph. First, you must decide on the best approach. Is a straightforward depiction of the subject on the table appropriate, or does the subject require an abstract treatment, unusual props, or other imaginative styling to be interesting? In other words, does the subject call for a special concept? Once you decide on the approach, you must give some thought to composition.

Strong still-life photographs rely in large part on the basic principles of composition. It is important for you to establish the relationships among the objects to be photographed, in terms of size, shape, color, reflective qualities, and texture. An understanding of perspective, as seen through the eye of the lens, will help you relate these elements to one another. In photography, depth of field determines the sharpness of each object pictured and, at the same time, establishes a sense of distance, a size scale, and the relative importance of each object. Do not hesitate to arrange, rearrange, and rearrange again and again until the composition is completely pleasing to the eye.

Color is another important element of composition. It is intertwined with lighting: the quality and amount of light can radically affect color values. Your photographs will be more effective if you know what happens to color (as well as shape) under different lighting conditions. For example, some colors, such as yellow, reflect light more than others do. As a result, a primary yellow probably would photograph best in a soft, diffused light.

The shape of an object as seen through the lens is affected by lighting conditions. The classic example is the egg. Illuminated from just one side, the oval appears elliptical. But when an oval shape is illuminated from above, it seems to flatten out. So with just a simple shifting of the lights, you can create this optical illusion as well as control the surface texture, contrast, and color balance.

As you contemplate each still-life image, keep in mind that your ultimate goal is to successfully combine all the photograph's elements: concept, composition, color, and shape. Making a photograph cohesive will enable you to create a striking, graphic image.

Such photographs, which I call "eye-stoppers," depend on previsualization. So, unlike photojournalism, in which the shooting ratio may be one strong image to every 36 actually shot, still-life photography has a dramatically higher ratio of usable pictures. For example, after testing with six Polaroids, you can achieve the desired effect in as few as four sheets of film.

Another fundamental you must consider is equipment. As you read the detailed descriptions of the photographs in this book, you will notice a consistency in the cameras and film used. I have found that standardizing equipment and mastering certain techniques are critical to successful still-life photography. It is important for you to become thoroughly familiar with your camera, the type of film you will use

most often, and lighting patterns. For example, by building a repertoire of techniques using different types of lighting—from strobe to tungsten spotlights—you will be able to set up shots quickly and efficiently in a number of situations. Having confidence in both your equipment and your techniques will eliminate the problem of unnecessary and time-consuming distractions. This will also free you to conceptualize your still-life images in a sensitive and creative way. Finally, your mastery of the medium will make your clients feel secure about their individual assignments.

Although choosing equipment and film is a matter of personal preference, I do suggest that you buy, borrow, or rent a 4 x 5 camera. Certainly, the 35mm camera has its place in still-life photography (in fact, you will see a number of photographs made with a 35mm camera here). But the larger-format camera is needed to capture the fine detail, line, or shape that characterizes many still-life subjects.

I would also like to offer a word of advice: Beware of becoming an equipment junkie. An obsession with acquiring the latest camera or accessory on the market can distract you from rather than facilitate your photography. If, however, you find yourself tempted to succumb to the newest technical wizardry, you should first rent the piece of equipment, test it, and evaluate the results in terms of what you already own and the type of work you usually do. Keep in mind that getting hired for one assignment in a particular area, such as stroboscopic stop action, does not necessarily mean that you will be called upon for a flood of similar assignments. Also, that one assignment certainly does not justify your immediately investing in specialized, high-priced strobe systems with limited application.

Beyond the creative and technical aspects of still-life photography are the more practical—but still vital—business concerns. I have found that the key to success is to maintain a broad base of clients. A certain degree of specialization in one area is an asset, while complete compartmentalization is a handicap. The photographs in this book represent a mixture of editorial, advertising, and self-promotional images. My careful execution of graphically demanding editorial assignments has, in turn, generated advertising work. These areas need not be mutually exclusive.

In addition to the editorial and advertising markets, consumer-product packaging, direct-mail catalogs, and corporate brochures offer a wide spectrum of commercial opportunities to still-life photographers. To position yourself well, begin by assessing your portfolio's strengths and your studio's capabilities. Doing some preliminary (although quite elementary) market research will help you focus on a potential client's specific needs. Find out what type of product(s) the client sells, as well as who the client's customers are. You should also study earlier promotional efforts and think about ways to improve on them.

Next, introduce yourself and your work by sending an eye-catching promotional piece to potential clients. Follow this up with telephone calls, portfolio presentations, drop-offs, and more mailers. When organizing your portfolio, remember that art directors and prospective clients usually have a limited amount of time to look at it. Put your best photographs in the front of your book so that you can grab their attention immediately. If, however, you are given the opportunity—and the time—to show your entire portfolio, be sure that the final images are strong enough to create a powerful, lasting impression. On other occasions, while it is dangerous to leave photographs "on spec-

ulation," you must sometimes make a judgment call and work with an agency or client directly in this manner.

Depending on your photographic specialty, your portfolio may contain transparencies, finished prints, and/or tearsheets. Avoid including a random assortment of different formats; consistency is essential. Put together your portfolio with the same care that you compose all of your images, keeping in mind the fundamentals of clarity, design, and attention to detail.

Approach the still-life marketplace with your strongest photographs. Show what you excel in; do not try to show the entire range of your imagery. Including experimental and test shots keeps your work fresh and creates excitement about your book, as well as utilizes free time effectively. For additional inspiration and advice, ask art directors for their comments on your portfolio's content and design. But remember not to take constructive criticism or rejection personally.

Through a trial-and-error system, most still-life photographers soon find their own successful strategy for selling and presenting their work. While the wining and dining of art directors and prospective clients sometimes elicits good feelings, it ordinarily does little except deplete your bank account. Stick with your pitch and price photographs competitively. Most important, concentrate on producing striking images and investing in self-promotional mailers or drop-off pieces that will eventually build a cumulative impression of the quality of your work.

Finally, do not wait for the telephone to ring: become an active participant in the promotion of your photography. Presenting your work yourself has two advantages. First, because you know your strengths and your images better than anyone else, you can describe both in detail. You will also learn the intricacies of the market. Eventually, though, as your business grows, you may need to find a representative to help sell your photographs, get appropriate assignments for you, handle negotiations, and serve as your business manager.

Begin this new business relationship with your representative, or *rep,* by devising a marketing strategy. Be sure to target your promotional efforts to a number of markets. Put together several different portfolios to show to various types of prospective clients. Consider exploring the frequently overlooked editorial market. It showcases photographs and offers high-quality art direction and design. The resulting tearsheets are outstanding. These, combined with the extensive name recognition that comes with the credit lines, are an effective form of promotion. Do not let the traditionally low fees stop you: the credits and the resale potential of the images make the editorial field an important part of any photographer's marketing strategy. Developing business in diverse markets will help keep you busy all year long. It will also enable you to establish a large network of freelance assistants, stylists, model makers, and other professional sources.

A final point: I hope that these pages reveal just how many hats the still-life photographer wears. A still-life photographer must not only be technically competent and completely familiar with an enormous variety of shooting approaches, but also adept at solving electrical problems, building sets, and improvising. In short, a still-life photographer is an electrician, engineer, carpenter, plumber, magician, stylist, designer, salesperson, negotiator, psychologist, and business expert. Being a still-life photographer is all-consuming, but I guarantee that it is never boring. The rewards of shooting still life—artistically, intellectually, and financially—are many.

POWER IMAGES

HOW TO SHOOT COMMANDING PHOTOGRAPHS

Although producing a powerful image that will stand out in a world inundated with visual stimuli may seem to be a formidable challenge, it can be done. But a fancy camera alone will not do it. Slick technique alone will not do it. A great picture begins with a great idea—an idea that goes beyond the obvious and helps to create a power image. Where do these images come from? How do they develop? In still-life photography, the object itself may be the inspiration: the shape of a vase, the texture of a fabric, the color of a lipstick. The photographs in this section offer a visual cross-section of what I call power images, drawn from advertising and editorial assignments. Some were self-directed; others were done in collaboration with an art director.

Approaches for still-life photographs abound. Look beyond the obvious. You do not have to be literal when depicting a product. In fact, a whimsical approach can be infinitely more effective. For example, I decided to place a bubble inside a client's C-clamp as I watched my toddler play with soapy bubbles up to her elbows. Interpretive rather than literal problem-solving is a wellspring of power images.

Equally striking is the clean, graphic composition with an unexpected touch. For example, by tying a simple, red-velvet bow on the champagne glass included here, I was able to capture the holiday spirit needed for a seasonal ad. There were no tricks, no lens distortion, no extraneous props. When it comes to props, I always find that less is more. Prop overkill is the amateur photographer's classic mistake. The ability to choose just the right prop might well be considered a still-life photographer's greatest asset. While stylists, designers, and art directors can offer their skills and opinions, the ultimate decision is up to the photographer. For the photograph of vases from the Museum of Modern Art's collection —which is one of my best portfolio pieces—I wanted only two twigs as props. This stark, unexpected arrangement contributed greatly to the picture's effectiveness.

The dramatic use of color is another technique for producing power images. While studying a table strewn with at least 100 lipsticks in different shades, I realized that I had to arrange them to present their bold, vibrant colors in an eye-catching way. Suddenly, it came to me: a zipper. Understanding the need for absolute color fidelity when shooting cosmetics, I knew that this photograph would prove to be a technical challenge, if not a nightmare. Nevertheless, recognizing the potential for a power image, I proceeded—and succeeded.

The creation of striking images often calls for abandoning time-tested techniques. A lighting pattern that works for one still-life arrangement may not enhance another composition, even if they are similar in content. Also, advertising and editorial clients want their concept presented in a unique fashion. A single, standard method of handling still-life subjects leads to stagnation—and fewer assignments.

Although photographic technique and equipment cannot help you produce power images by themselves, they are integral components. Developing an intimate understanding of lens capabilities is particularly important. You should have a variety of high-quality, high-performing lenses readily accessible. Medium to long lenses compress images, altering the perspective of distance without violent distortion. Closeup lenses magnify fine detail without any distortion at all. Macro lenses go even further in enlarging detail and transmitting visual information that might otherwise be lost. Remember, though, that shock value alone does not make an image powerful, so use lenses discretely and purposefully.

Experimenting with different formats can also enable you to reach new creative heights. The swings and tilts of a sophisticated view camera—whether it's a 4 x 5 or an 8 x 10—make perspective control possible. This, in turn, allows for increased depth of field and parallel-line correction, enabling you to execute exciting components. The lipstick photograph shown here demonstrates the powerful result of tilting the front standard of a view camera.

Finally, a working knowledge of the effects of various photographic accessories can turn good pictures into great ones. For example, to transform an ordinary backdrop into an extraordinary one, you may need to change only the lighting. Placing colored gels over lights can alter tones on a background. Using snoots and barn doors over lights can control their direction and intensity as well as create tonal effects ranging from light to dark. An even more basic transformation is to switch to a different background material. Beyond standard seamless paper, you can try Varitone, a flexible, acrylic-coated material; milky Plexiglas; and stressed aluminum, among other metals. You can commission a custom-made background, too. The possibilities are endless.

Perhaps the most common characteristic of power images is the introduction of the unexpected. This is not merely placing a small object near a large one or a rough texture next to a smooth surface; it is the juxtaposition of the main subject with an unusual object, such as the clamp with the bubble. In this shot, the tool's jaws, which are ordinarily clamped around wood or metal, hold a fragile bubble. Equally captivating is the addition of a subtle prop instead of an anticipated element, such as the sparse twigs rather than a huge, splashy bouquet in the Aalto vases. Props should enhance, not overpower, the principal subject. Finally, do not be afraid to experiment with new concepts that include unusual props. After all, experimentation leads to experience—and power images.

A RADICAL TREATMENT

For this assignment, Brink & Cotton hired me to photograph a C-clamp for a trade advertisement. Armed with only vague notions, the client asked me to provide both a concept and a budget. As I studied the C-clamp on my studio table, I became fascinated with the idea of juxtaposing this heavy, imposing-looking object with something light and delicate. When I saw my toddler blowing bubbles later that afternoon, the idea jelled. The client was initially excited by this unusual approach but soon reconsidered, feeling apprehensive about the budget—and the feasibility of my idea. By this time, however, the technical challenge of compressing a soap bubble in a C-clamp so fascinated me that I decided to shoot the image for a portfolio piece.

Because I wanted the C-clamp to appear to be floating in space, I positioned a lightstand with a thin, black crossbar attached to it behind a sheet of black seamless. Next, I cut a hole in the seamless and positioned the crossbar through the hole; the bar protruded approximately 2 feet. With the aid of a hot-glue gun, I affixed the back of the C-clamp vertically to the end of the bar. Then, by maneuvering the camera up and down slightly, I found the angle that eliminated any trace of the crossbar support, thereby achieving the desired floating effect.

The next task was to set up the lighting equipment. I decided to use an overhead medium-size Chimera bank light with one Speedotron 2,400 watt-second strobe head. This created bright highlights with full textured detail that I contrasted with dark areas. I then placed three 8 x 10 silver cards around the C-clamp, one on either side and one underneath, to fully outline the clamp and to reflect light into the bubble once it was in place.

With the lighting pattern established, my assistant, Carol Hess, experimented with how to best position the fragile bubble in the jaws of the C-clamp. At the same time, I practiced stabilizing the bubble once it was in position. Anticipating this difficulty, I had located a plumber's O-ring and placed it on the lower jaw of the clamp. Nearly invisible, the O-ring secured the bubble. Although the bubbles proved difficult to handle, Hess soon perfected her technique, which consisted of blowing a bubble, catching it with a wand, and transporting it to the O-ring. With the cable release in one hand, all that remained for me to do was to carefully turn the C-clamp screw until it just kissed the top of the bubble and to fire.

To best capture this image, I decided to use my favorite Sinar 4 x 5 view camera with a Schneider Symmar 210mm lens. The grid on the groundglass helped ensure the vertical line of the C-clamp. The 4 x 5 field of view also provided image clarity and minimized distortion. After perfecting the technique by making numerous Polaroid tests, cleaning the clamp with a cotton swab, refocusing, and replacing the burst bubble after each shot—I moved on to Ektachrome 64 daylight-balanced film and exposed eight sheets for 1/60 sec. at *f*/22. Rather than bracket, I shot all the frames at this basic exposure and then processed one sheet normal. Once I viewed the test exposure, I proceeded to process the remaining batch at a 1/2-stop push for added bubble brightness and increased contrast.

An ordinary glass bubble, supplied by a model maker, might have been easier to photograph than an actual bubble. Before beginning, I researched using a glass bubble, but found it to be visually weak when compared to a real one. That marvelous authentic glisten was somehow missing, even in the best impostor. Also, a glass bubble would not have posed nearly the technical or logistical challenge that the genuine article offered.

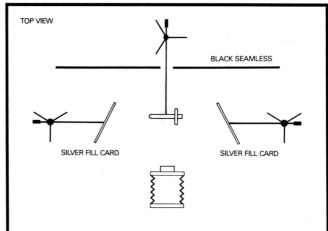

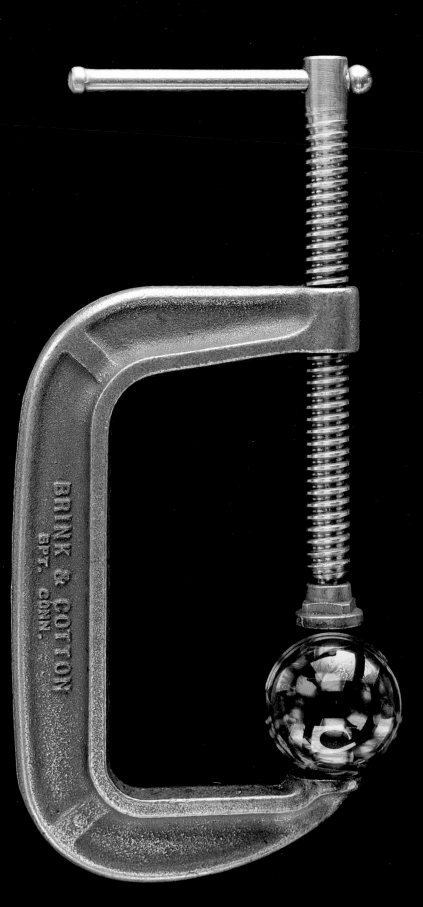

AN ARTISTIC APPROACH

This image was produced as a color advertisement from a continuous-tone, black-and-white print, shown below. The client, Food & Wines from France, had a limited budget for this shot so four-color reproduction was ruled out. During the preproduction meeting, Jane Rubini, an art director with TBWA Advertising, Inc., in New York City, production manager Steve Shapiro, and I explored the idea of shooting in black and white and reproducing the ad in a two-color duotone. The working layout, which called for a tight closeup of a filled champagne glass "tied" with a red bow, lent itself visually to this process. Because the client loved the offbeat approach and the numbers worked, we proceeded.

Upon receiving the approved layout, I asked my assistant to buy high-quality, clear champagne glasses with a simple classic design. For the bow, I chose a slightly lighter-colored red ribbon than the one shown in the layout because I knew that the color would drop in density during exposure. On the day of the shoot, stylist Carla Capalbo steamed six lengths of ribbon until they were wrinkle-free. After much practice, she tied a perfect bow around the glass, which was then mounted on a narrow shelf suspended between two lightstands. The opaque, white rolling flat I had chosen for an unobtrusive background was positioned 4 feet behind the set.

At this point, I turned my attention to the lighting equipment. I decided to use a Pro-3 4,800 watt-second strobe unit because of its brief flash duration, which I needed to capture the fast motion of the champagne bubbles. On either side of the opaque flat, I placed a head equipped with a 90-degree, 6-inch reflector at a 45-degree angle. The illumination from the heads bounced off the background and created a large, indirect light source. I then set the strobe at 2,400 watt-seconds (1,200 watt-seconds per head) to achieve a flash duration of 1/800 sec.; this successfully froze the champagne bubbles. The basic exposure was 1/60 sec. at f/22. Now, I just needed to add finishing touches. I mounted a small mirror on a tripod swivel head, which was positioned in front of the glass, and adjusted it to bounce light onto only the bow. Completing the lighting pattern, I hung black cards in and around the set to create a black window, to eliminate flare.

Working without a retouching budget for this assignment meant that combining the right camera with the right lens and the right film was critical. I chose my equipment carefully to ensure the technical accuracy of this image. I used a Sinar 4 x 5 view camera mounted on a Bogen camera stand. I selected a Schneider Repro-Claron 210mm f/8 lens because of its superb flare control when recording such highly reflective objects as glass or jewelry. I shot six Polaroid 4 x 5 (Type 52, ISO 400) tests to balance the backlight with the front ribbon fill light. The results prompted me to use black-and-white Royal Pan film (ISO 400) for its speed, medium contrast, and brilliant highlight detail.

Finally, after Capalbo siphoned off the flat champagne with a turkey baster and added fresh, bubbly champagne, I exposed six sheets of film. These were then processed in D-76 by hand in a tray and turned out to be well-balanced negatives, which were then printed on a #3-grade paper for additional snap. The black-and-white duotone treatment gave the image an artistic flair with a hand-tinted feel. The client was thrilled with the result: its concept had been realized in an unexpectedly creative way.

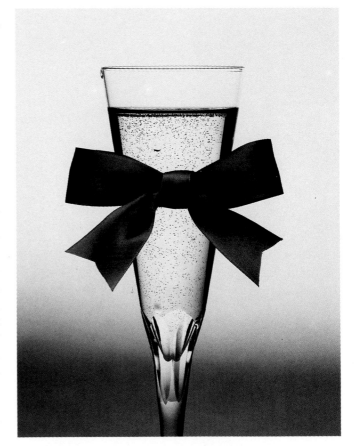

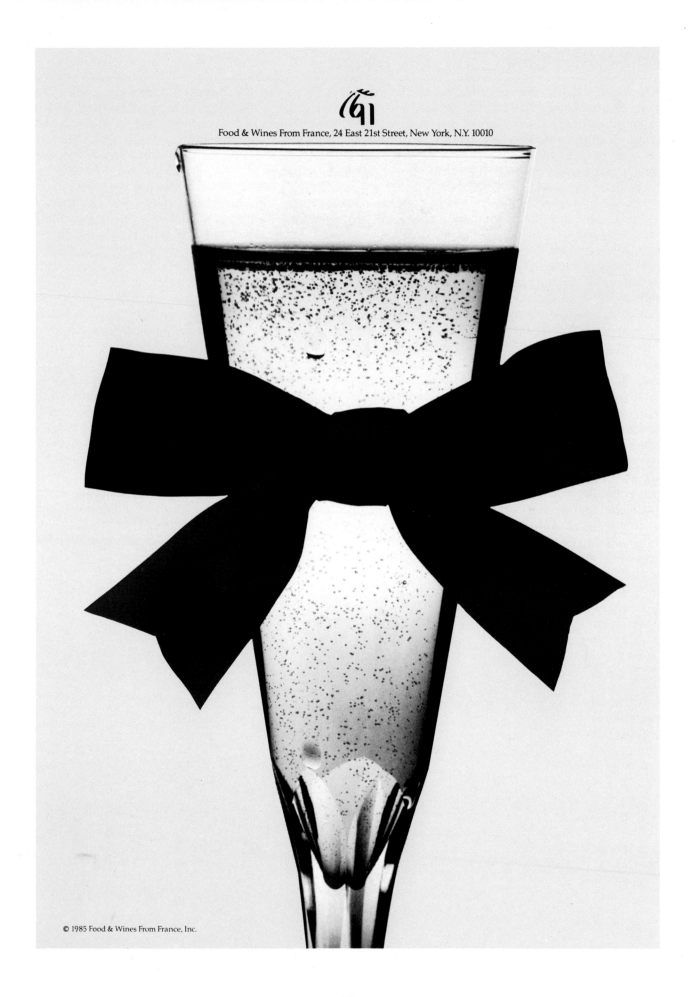

SIMPLE BUT EFFECTIVE PROPPING

Precious objects in a museum collection are, by their nature, examples of outstanding design, and any photograph of them must capture this quality. The lighting setup must be flawless, and while dramatic effects are permissible, they must not be extreme. When shooting museum pieces, you must also carefully evaluate the props that will be included. Do they enhance the objects? Do they help convey the mood properly? Thoughtful composition is essential to effective images.

I was hired by New York City's Museum of Modern Art to photograph these famous Alvar Aalto vases for the cover of its Christmas catalog. The head of the design department did not have a specific layout in mind, but wanted a memorable cover image to set an elegant tone for the rest of the catalog.

Propping the vases proved to be my biggest challenge during this assignment. To keep the composition uncluttered, I decided to do it myself. I spent a great deal of time thinking about, choosing, and arranging the few stark twigs and berries that established the objects as vases. The twigs also provided discrete diagonal lines without obscuring the beautiful lines of the crystal vases' design.

My next concern was the lighting. Because displaying the simple shapes was paramount, I decided to backlight the vases in order to silhouette them. The set consisted of a 4 x 8-foot sheet of Plexiglas, which had been sandblasted to give it a matte finish. This finish cut down considerably the inevitable reflections that threatened to cloud the clarity of the crystal. My assistant put the Plexiglas on a tabletop, folded the back end up, and clamped it to a crossbar to form a *sweep,* a piece of plastic that is curved to create the illusion of a seamless expanse. The sweep served as a lightbox behind the vases. I then placed a large, Lowel 1,000-watt-second, tungsten reflector floodlight behind the sweep. In order to convey the Christmas look that the museum desired for the catalog, I placed two green gels partially over the front of the light. This provided the image's diffused green foreground. The holiday motif was echoed by the red berries and pine twigs.

My Sinar 4 x 5 view camera proved to be ideal for this photograph. The grid pattern on the ground-glass helped to control the parallel lines—both vertical and horizontal—thereby making the picture clean and sharp. After exposing and evaluating six Polaroids (Type 52, ISO 400), I was satisfied with the arrangement of the vases and the light levels. I then switched to Ektachrome 50 tungsten-balanced film and exposed four frames, bracketing as I shot. The basic exposure was 8 sec. at f/22, with 1/4-stop increments in either direction. Interestingly, this basic exposure produced the most effective image.

If all this sounds relatively easy, it should: that was the original idea. When shooting simple art objects, you must find a way to highlight their lines without complicating the image. These are assignments in which less is clearly more.

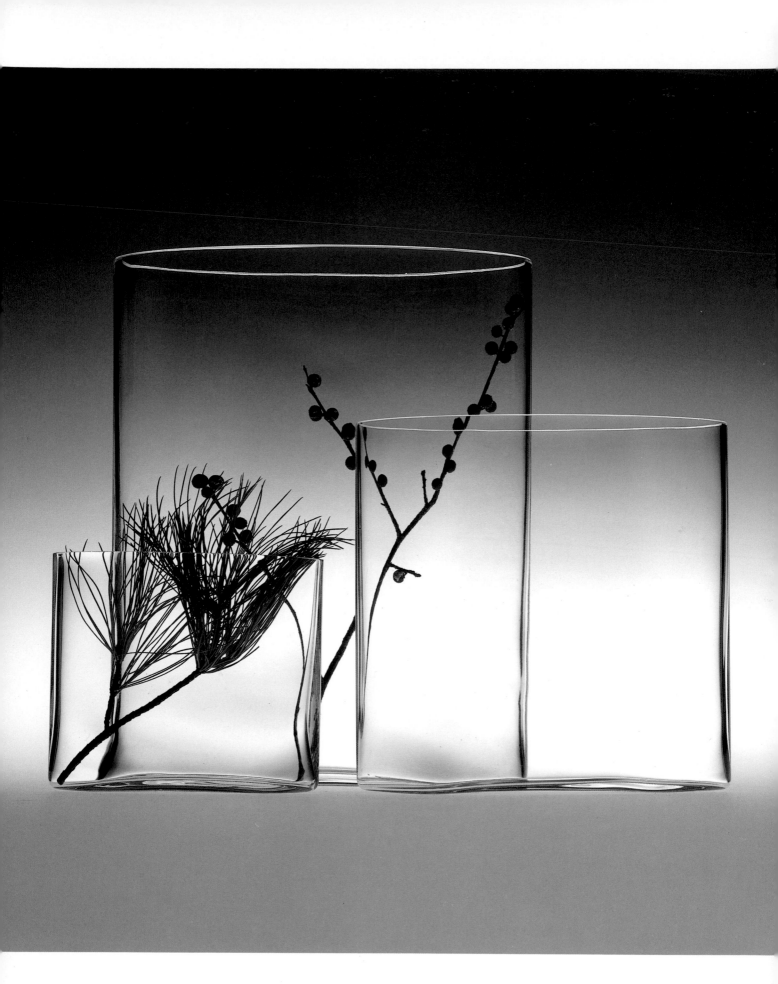

TURNING A CLICHÉ INTO A CLASSIC

Clocks and watches fascinate advertisers as a means of illustration. The challenge for the still-life photographer is to make this clichéd device fresh and provocative. I was required to do just that when I was hired to shoot a recruitment advertisement for GTE. The creative staff at Bernard Hodes, Telephone Marketing Services, Inc., a division of the Doyle Dane Bernbach advertising agency, visualized the inner workings of a watch advertisement. During a pre-production meeting with Cheryl Kaplan, the creative director at Bernard Hodes, and Carla Capalbo, a highly specialized prop stylist, we discussed the type of watch that would be appropriate for the poster-like image we wanted. Capalbo then set out to scour the collections of various jewelers that specialize in fine watches and gathered a large assortment of wristwatches, pocket watches, and chains. On the day of the shoot, Kaplan and I reviewed the selection and agreed on a classic gold pocket watch.

Knowing in advance both the amount and the location of the space reserved for copy in the layout, I proceeded to work around it as I composed the image. I placed the pocket watch, the principal visual element, on the beige-marble background so that the watch would be in the top center portion of the advertisement. To enhance the vein patterns, I decided to sprinkle the marble with Kaplan's blue eyeshadow and rubbed it in. The next step was to position the camera, moving in close to the watch in order to get the largest image possible on the film.

As for equipment, I chose a Sinar 4 x 5 view camera and a Schneider Repro-Claron 210mm lens to capture the detail in the small object. Then I started to refine the image as it appeared through the groundglass. My next task was to arrange the lighting equipment. Wanting to spotlight the watch's internal mechanism, I attached a 6-inch reflector and a #2 grid to a Speedotron head. I then mounted the head on a boom and lowered it until it was directly above the watch. After shooting four Polaroid (Type 52, ISO 400—my favorite black-and-white film for testing because of its ability to record highlight and shadow detail) tests, I moved to Ektachrome 64 daylight-balanced film and exposed for 1/60 sec. at f/22. I also bracketed 1/2 stop in either direction. But the basic exposure (1/60 sec. at f/22) turned out best.

You will find that, too often, photomacrography is used merely to achieve a different look. I prefer to shoot extreme closeups to clarify a point rather than to shock viewers. As a result, the photographs become a tool for genuine communication. Here, a closeup was appropriate because the inner workings of the pocket watch created a strong visual image and, without some magnification, would have been lost to the naked eye. Be discriminating when you consider subjects for photomacrography. GTE was so pleased with the final result that it bought prime space for the advertisement.

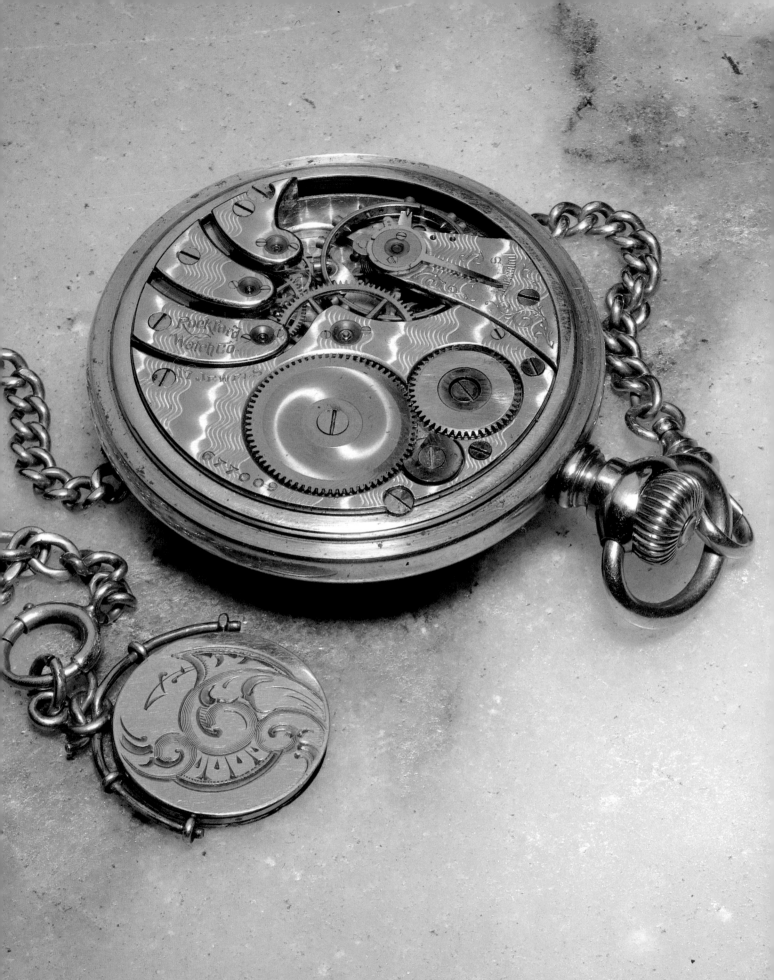

AN INNOVATIVE COMPOSITION

This image grew out of my plan to make a highly provocative, conceptual self-promotional piece. I wanted to introduce my work to major cosmetic companies. I decided to shoot lipsticks because they are so common: many successful photographs are the result of shooting familiar objects in an unexpected manner. Lipsticks have probably been photographed in almost every conceivable way—except, until now perhaps, as a zipper. The idea intrigued me. I invested in about 100 lipsticks and experimented with different designs and patterns for more than a week. Suddenly, I was struck by the way the lipsticks linked together; they reminded me of a zipper on a storm coat. All I needed to complete the arrangement was a zipper pull.

What appears to be 50 lipsticks is actually only 25. When I began photographing, I used only one zipper pull, which I left fully open at the top. But when I checked the Polaroid tests, I immediately noticed that I could create an even more exciting perspective by shooting a second, identical image and butting it against the original. The final composite photograph was achieved in a processing laboratory, where the seam was removed by retouching.

Once I resolved the creative questions, I focused on technical matters. Color rendition was critical. Cosmetic companies are, understandably, zealous about the accuracy of the shades of their products. So although I was certain that the zipper concept would grab their attention, I also had to demonstrate my ability to accurately capture lip color. This, of course, starts with lighting. I used a medium-size Chimera bank light with a single Speedotron strobe head, set at 2,400 watt-seconds and lowered from

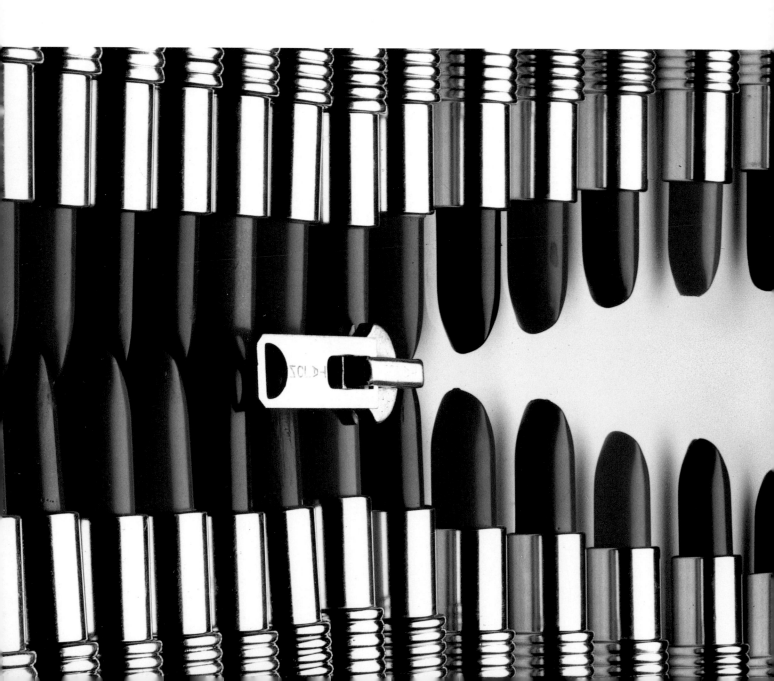

above on a Bogen boom. This lighting arrangement was an ideal choice: it highlighted the gold cases, created a luminous sheen on the lipstick colors, and made each color distinct, despite the almost mono-chromatic shading in some areas. As such, the bank light established the lipstick colors accurately and highlighted tones in the composition.

Next, with the lighting pattern set, I determined which equipment to use. I chose my favorite Sinar 4 x 5 view camera and a Schneider Symmar 210mm lens, whose forward tilt provides added depth of field. After shooting several Polaroid (Type 52, ISO 400) tests to check both the exposure and the proper alignment of all the lipstick tips, I switched to Ek-tachrome 64 daylight-balanced film for the final pho-tographs. It took me an entire day to lay out the lipsticks so that they would link together symmetri-cally. I positioned them carefully so that I would not damage the tips. With the shutter open and the ap-erture set at $f/64$, I popped the strobe four times, waiting for it to recycle completely after each pop. I then exposed five sheets: one sheet each at three, five, and six pops, and two sheets at four pops, the prime exposure. Throughout the duration of this multiple-pop exposure, the studio was blacked out and the modeling light was turned off.

This self-promotional piece attracted the attention of Avon and Revlon. Avon suggested using the cap-tion "Zip into fall colors" with this concept. Although the original image itself did not sell, Avon was im-pressed that I had presented a commonplace prod-uct with a creative flair and hired me for an assignment. Displaying initiative can lead to impor-tant contacts—and work.

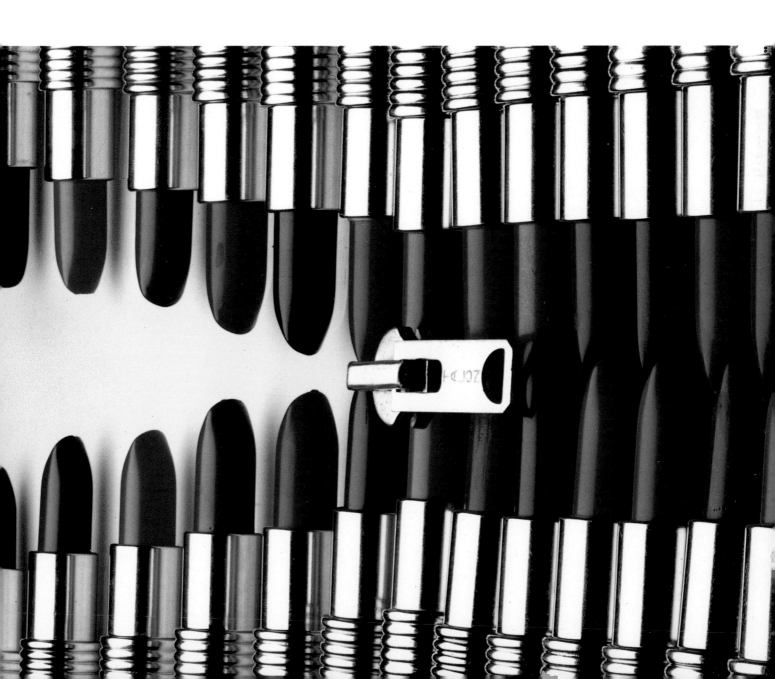

PLANNING A SUBDUED SEDUCTION

This photograph was included in a 20-page spring catalog featuring merchandise from D.H. Holmes, a New Orleans retail store. Daryl Herman, the art director of Harrison Services, Inc., a New York City–based design firm, offered me the assignment. We had worked together before, and he was aware of my location-shooting background. In order to determine the most effective strategy, Herman arranged a preproduction meeting. The fashion photographer hired to photograph the models, Herman, and I immediately agreed that catalog shots do not have to be boring—or predictable. We also discussed how the light on location or in a studio with ample daylight can help create striking images that still meet a catalog's need for clarity. The three of us then decided to rent a studio with strong illumination to achieve a natural look.

Next, we located an apartment available for a five-day rental; it had both unusual furnishings and brilliant window light. Photographing the models and the products using a similar lighting pattern would guarantee visual harmony in the catalog. This was a major concern of the art director. To this end, Herman laid out each spread in advance on the morning of the day it was to be shot.

By making visual consistency a goal, everyone involved with the shoot achieved a rare unity of concept, design, and execution. The fashion photographer and I shot on the same 2 1/4 Ektachrome emulsion, using Hasselblad cameras. Also, we both used either white cards or 800 watt-second Dyna-Lite strobe units as fill light. Finally, all of our color film was processed by the same lab to ensure uniform color quality.

By the third day of the shoot, I had had ample opportunity to observe the shifting patterns of natural light. The design on the carpet created by the window blinds was ideal for a small-product shot for the catalog. I decided to take advantage of this lighting pattern when I photographed a bottle of expensive perfume. The granite base of the coffee table became the background for the shot. The natural light emphasized the texture of the rug, adding a sense of depth and an air of elegance to the picture. For this image, I fastened my Hasselblad camera to the lower end of the tripod leg using a Leitz camera clamp. Then, by mounting an extension tube on a 120mm lens, I was able to fill the frame with the small bottle. Once the composition was arranged, I positioned a white fill card to reflect light back onto the bottle's black stopper.

At this point, I was working quickly. The light was changing every minute, altering the pattern cast on the carpet. Twice, it was necessary for my assistant, Ken Maguire, to move the bottle about 6 inches to adjust for the shifting light pattern. Because I had no time for Polaroid testing, I made a reflective-light reading with a Luna-Pro meter and shot an entire roll of Ektachrome 120 (ISO 64) film. The basic exposure was 1/2 sec. at f/16. I bracketed 1/2 stops in either direction and processed the roll normal. The results were just what I had hoped for: a fresh-looking photograph with rich highlights that outlined the shape of the bottle and provided the elegance needed to attract customers.

A final thought about location shooting: To capitalize on spontaneity and unpredictable conditions, be prepared. For example, take along extra equipment. In this case, I was thankful that I had a Leitz camera clamp with me. It enabled me to shoot at an unusual low angle, which is time-consuming and awkward to do with an ordinary tripod.

HOW TO MAKE FAMILIAR OBJECTS LOOK SPECTACULAR

One of the most predominant images in advertising is that of people enjoying themselves while drinking various beverages: fruit drinks, soda, beer, wine, liquor. Because these pictures are the source of a great deal of revenue for photographers, you should master the techniques of making inviting images early in your career. Whatever the beverage—sparkling water, champagne, fruit juice, or soda—fresh concepts are always in great demand and rely on sensory appeal and viewer seduction. This can be a lifestyle seduction, such as the café shot in this section, or a far more technical seduction, such as the Heineken photograph. Shooting the beer bottle required an understanding of the effects of condensation, as well as knowing how to create these effects and how to capture them on film.

Most beverage photographs are the result of one of these two approaches: the closeup product shot or the lifestyle shot. Each one has specific requirements. The basic elements of the product shot are the beverage and the bottle or container's shape, label, and color. The challenge here is to show familiar objects in a way never before seen. First, study the liquid. Is it bubbly? Is it clear or colored? What happens to it at different temperatures: does condensation or frost form on the bottle? If the bottle is shaken, will the beverage explode?

Opportunities for dramatic still-life images abound, but you may have to provide a little assistance. To produce the effect of water droplets on a bottle, you can spray it first with Crystal Clear, an acrylic coating that glazes the surfaces, and then with water. Acrylic ice cubes come in handy, too; in fact, I keep a generous supply in my studio. Skilled model makers can create devices that simulate all types of liquid properties and that stand up through hot lights and lengthy photo sessions. For example, they can provide endless effervescence in the form of acrylic bubbles. Special effects provide creative solutions without violating truth-in-advertising regulations.

Next, consider the bottle. Its shape was carefully developed by sophisticated designers to ensure consumer appeal. Your task is to maximize this appeal without the benefit of touch. Are there curves that can be successfully enhanced by lighting? Is there a color—that of the bottle itself or on the label—that can be contrasted or complemented by a particular background or props? Is the label design strong enough graphically to warrant a closeup? Conversely, can you blur, obscure, or otherwise take liberties with the label without upsetting the client?

Obviously, you must answer many questions regarding composition long before you begin to actually shoot.

Lighting patterns also can make beverage shots look compelling without having to be complicated. Simple underlighting produces such intense color saturation that the image clearly pops from the paper. Backlighting provides a sharp edge, which is particularly effective with clear bottles filled with colored liquids. Sidelighting wraps beautifully around bottles and falls off gently, forming a heightened sense of roundness. Obviously, no standard lighting patterns exist. Each bottle's characteristics point you to the appropriate lighting setup.

Camera angles play a major role in creating innovative imagery as well. While a bird's-eye view is always effective, shooting from the inside out can be dramatic, too. I used this technique for the photograph of Four Roses whiskey in this section. To accomplish this product shot, I carefully broke a bottle and placed my lens inside it. I went through at least six bottles before I was satisfied with the images, so be sure to have an adequate supply of the product on hand. While many photographers are often apprehensive about utilizing the distortion capabilities of lenses because they do not wish to offend clients or misrepresent products, I find that clients often appreciate fresh viewpoints. Even with lens distortion, products remain readily recognizable. Blurring an image in a product shot is also effective. The picture of Chivas Regal shown here demonstrates how motion can suggest someone reaching for the product. Product shots rarely need to be boring or predictable.

In lifestyle photography, the other common approach to shooting beverages, the basic premise is to associate the product with the way of life the target audience currently enjoys or aspires to. While these images

appear to be spontaneous, they are completely planned and arranged. The challenge you face is to prevent the image from looking staged. To accomplish this feat, you first have to establish the concept. This is usually a joint creative effort involving you, the advertising agency, and the client. Once the desired lifestyle is decided upon, you—or specialists you hire—must do an enormous amount of legwork and organizing before you lift your camera. This includes scouting locations for the right apartment, a glamorous theater lobby, a railroad station, or a country field and finding the appropriate props. Casting is also critical: the models must represent the targeted market. Finally, the product is worked into the chosen environment.

While most lifestyle photographs are thoughtfully planned and executed, there are some rare exceptions. At the opposite end of the lifestyle spectrum are what I call the accidental images. These pictures seem to compose themselves with just a minimum amount of help from the photographer. For example, the shot of a café closeup in this section shows an everyday scene that I stumbled upon on Majorca. With just a few minor adjustments and some gentle persuasion, the native "model" cooperated and I was able to capture a bistro atmosphere for a photograph of wine. I shot this image with only a Nikkormat 35mm camera and an 85mm lens. Product shots, on the other hand, can be complex and require a great deal of equipment.

As a major market for advertising photography, the beverage industry is worth cultivating. Doing test shots without the benefit of client-backing frequently pays off in terms of self-promotion. Although these experimental, self-directed photographs never appear in a finished ad, they may open doors to new assignments.

AN UNUSUAL POUR SHOT

Photographs that show liquids being poured are among the most technically demanding images still-life photographers can produce. Because pour shots look dynamic, most photographers include several variations in their portfolios. This image of a Four Roses bottle is the result of an unusual perspective: I decided to parody the pour shot by shooting from inside a liquor bottle looking out. Knowing that I needed a plain bottle with an attractive, poster-like label that would read clearly, I was pleased when I found the Four Roses bottle in the liquor store. I bought four bottles: having an adequate supply of the subject (when possible) and props is essential.

Back in my studio, I proceeded to remove the base of the bottle with an ordinary bottle cutter. I succeeded in getting a clean break three bottles later. Next, Ken Maguire, my key assistant, steamed off the label, reversed it, and spray-mounted it back on the bottle. With a hot-glue gun, I attached a 1/4-20 T-nut to the edge of the cut base; this allowed me to securely mount the bottle onto a Gitzo tripod. Now, with maximum control of the bottle, I tilted it at a 45-degree angle to the floor. My choice of optics was a Schneider Super Angulon 65mm lens on my Sinar 4 x 5 view camera. This extreme wide-angle lens, which I moved to the very edge of the cut end of the bottle, created the image's abstract perspective.

Next, I roughly composed the picture and focused the camera. As I observed the image through the groundglass, Maguire slowly maneuvered the bottle forward until it completely surrounded the lens. After I made my final adjustments and was satisfied with the positions of both the bottle and the lens, I faced the challenge of critical focus. Because the Super Angulon 65mm lens is a slow lens, it is difficult to focus. Everything appears sharp but dark. To overcome this problem, I asked Maguire to set up a 1,000-watt focusing light: this would brighten the image on the groundglass. It also allowed me to periodically stop down the lens to *f*/22 (the aperture I intended to expose at) and view the depth of field as it would appear on film. After experimenting with different camera movements and focusing positions, I was ready to illuminate the set.

First, my assistant lowered a medium-size Chimera bank light with a 2,400 watt-second Speedotron head to just above the bottle. Maguire's next step was to mount silver cards on lightstands along both sides of the set. These reflected highlights along the seams of the bottle. After shooting a black-and-white Polaroid (Type 52) at *f*/22 for 1/60 sec. and evaluating the result, I decided to add two small pieces of red Color Aid over parts of the silver cards in order to enhance the bottle reflections. At this point, I shot a color Polaroid (Type 59), adjusted the red cards slightly, determined that the image was reading well now, corked the bottle, and filled the neck of the bottle with Four Roses. To shoot the final color Polaroid, Maguire pulled out the cork as I fired the shutter. (The liquid ran out into a bucket.)

Pleased with this test shot, I had Maguire refill the bottle by using a plastic "squeeze" container. At the same time, I loaded the camera with Ektachrome 64 daylight-balanced film. I then made six exposures at the basic exposure of *f*/22 for 1/60 sec. Naturally, my assistant refilled the bottle after each shot. Upon seeing the film that had been processed normal, I had the remaining sheets pushed 1/4 stop.

Although pour shots pose technical challenges and demand expertise, most commercial photographers have several striking examples in their portfolios. They know that potential clients appreciate the expertise demanded to achieve such eye-catching images. Whether "pour" shots are tack sharp to freeze the action of the liquid or blurred to convey a sense of motion, they are an asset.

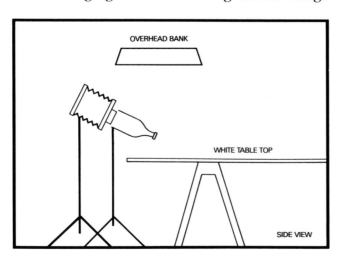

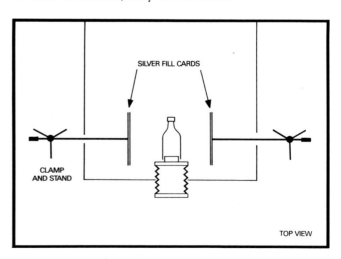

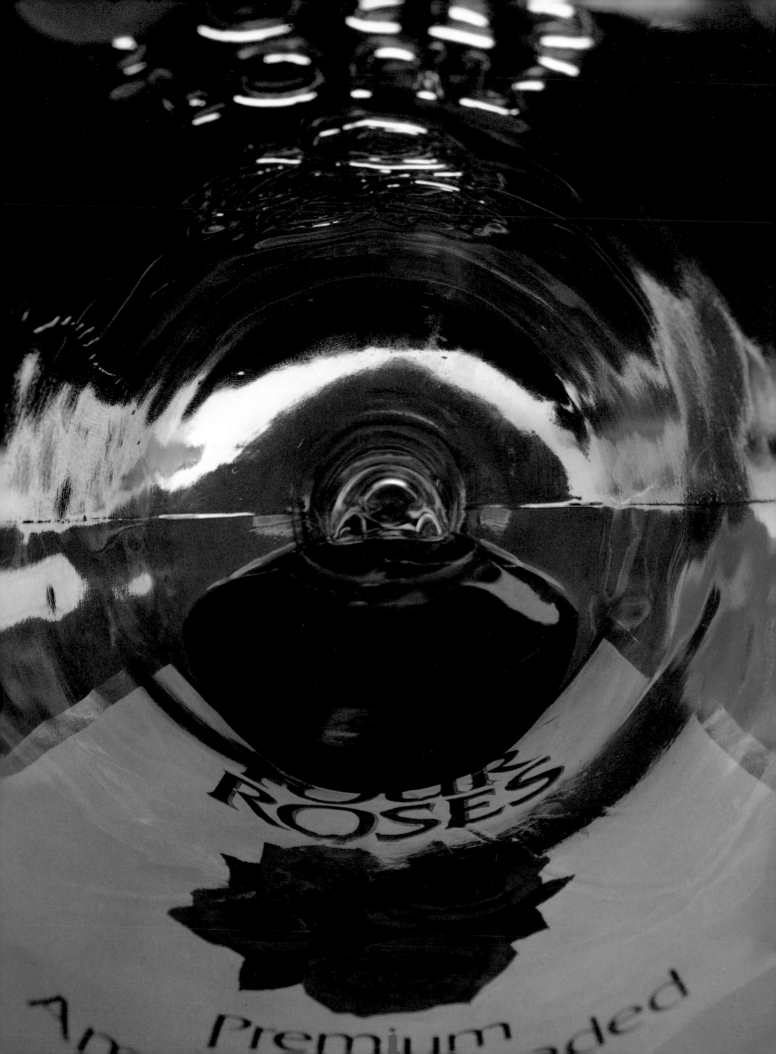

THE IMPACT OF A DRAMATIC PERSPECTIVE

Always keeping my eyes open for marketing trends, I noticed several years ago that imported beer was making a big splash. Heineken beer's emerging popularity led me to research the print campaign that the beer's importer, Van Munching & Co., Inc., had approved. When I saw it, I decided to try a radical concept. I wanted to take advantage of the Heineken bottle's shape, color, and logo, and to create an unexpected and exciting visual through my choice of lighting, camera angle, and lens. My primary intention was to add an innovative portfolio piece, not necessarily to land a major beer account. As such, I had complete freedom.

Out of the way of daily studio activity, I built a small set that I could leave up and experiment with when time allowed. I cut a 1-inch round circle out of a roll of black flock paper and spray-mounted the paper to a 1/4-inch-thick sheet of milky Plexiglas. I balanced the Plexiglas on two sawhorses in order to place a light below it; this would create a lightbox effect around the cutout. I then sprayed a Heineken bottle with Crystal Clear, an acrylic coating that dries clear and allows drops of water to adhere to its surface. (It is available in most art-supply stores.) Next, I also sprayed a stainless-steel bottle opener with Crystal Clear, placed the bottle over the cutout, and then clamped the bottle opener, which had dried, onto a lightstand, permanently positioning the bottle opener over the bottle cap.

I was now ready to consider the format for the photograph. To create a dramatic wide-angle perspective, I decided to shoot from above the set with a Sinar 4 x 5 view camera. With the aid of a 500-watt tungsten focusing light, I composed the image with a Schneider Super Angulon 90mm lens, but did not think that the result was dramatic enough. Switching to a Super Angulon 65mm lens put me just inches from the bottle top yet produced the exact wide-angle perspective I wanted.

The image's success now depended on a balanced lighting pattern. For the key light, I chose a small strobe bank light. I positioned it above the bottle top and angled it toward the lens to concentrate the light on the point of focus, the bottle cap. The opener, however, caught some of the bank light's illumination, adding contrast to the image. As the light trav-eled down the bottle, it progressively darkened and provided a sense of depth. I then placed another strobe head with an optical snoot under the Plexiglas "table" and focused on the round cutout, illuminating the bottle from below. As a result, the bottle glowed a vivid green, and its shape was separated clearly from the black background.

The test shots came next. With the lens stopped down to *f*/22, I shot black-and-white, positive/negative Polaroid film (Type 55) to check both the balance of the strobe lights and sharpness. Because selective focus was critical for this image, I viewed the Polaroid negative with a 5X magnifier to verify sharp focus. Then, with my view camera loaded with Ektachrome 64 daylight-balanced film, I was just about ready to shoot. I masked the background and sprayed the bottle and opener with water. I shot two frames and then sprayed again, slowly building up the water droplets. I removed stray drops with a cotton swab. As the "sweat" began to build up on the bottle, the green color saturated the droplets. I exposed 10 sheets of film. Numerous variations of push- and pull-processing provided me with many color choices.

Over the course of a week, I went back to the set, experimenting with various approaches: I changed the amounts of water droplets, and I tested different lighting ratios. After shooting many sheets of film, I was finally satisfied that I had created a fresh and provocative piece for my portfolio.

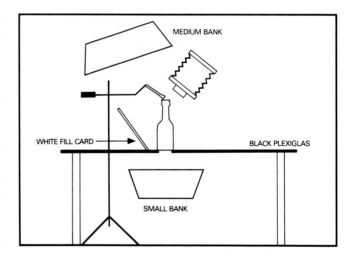

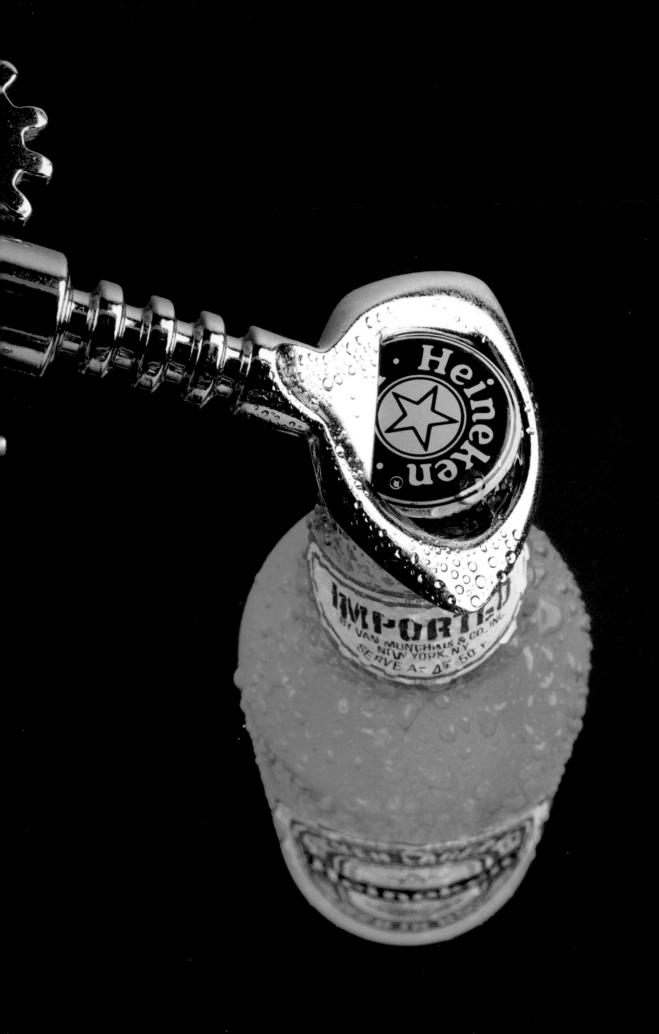

THE BLUR EFFECT

Adding a sense of motion to still-life photography has always intrigued me. The imaginative use of "blur" on a still-life subject is an exciting approach: it can make a common product shot distinctive. When I decided to do this shot, my primary intention was to illustrate the "life" that motion gives a static object. The resulting image both helped me to achieve my goal and enabled me to perfect my technique in a new portfolio piece.

To maximize the blur effect, I wanted a reflective object that I could shoot against a black background. The gold label and orange tones of the Chivas Regal bottle fit my specifications perfectly. Next, keeping in mind that the simplest way to capture a blur on film is to double-expose the image by moving the camera during the second exposure, I chose a Sinar 4 x 5 view camera, mounted on a tripod with a swivel head, and a Schneider Symmar 210mm lens. The large format allowed me to trace the outline of the bottle image on the groundglass with a red grease pencil. This sketch, in turn, enabled me to go back to the exact position used for the first exposure after each double-exposure sequence. I then turned my attention to my assistant, Carol Hess, watching as she placed the Chivas Regal bottle on the set and attached the can to the neck of the bottle by using a hot-glue gun. The black background that my assistant had hung 6 feet behind the set helped to eliminate any stray light that would have weakened the blur saturation of the second exposure.

Next, Hess positioned a medium-size bank light with a Speedotron head set at 2,400 watt-seconds on the blur side of the liquor bottle. I put a silver card, cut to the approximate shape of the bottle, behind the set to reflect light through the glass. Finally, a large, white rolling flat was set on the left side of the bottle to open up the shadow and to reflect light onto the label of the bottle.

The first shot, which established the image, was exposed in total darkness on Ektachrome 64 daylight-balanced film for 1/60 sec. at *f*/32. Still in total darkness, I adjusted my equipment for the second exposure. I opened the shutter to "Bulb" and changed the aperture setting to *f*/5.6, its widest opening. Then, on the count of three, my assistant switched on the tungsten modeling light for the Speedotron. As the light came on, I turned the camera slowly to the left, causing a blur to appear on the right side of the label. Because I moved the camera manually, I counted to four before closing the shutter to end the exposure. This helped me determine the length of time needed to register the blur, so I could bracket the exposure and then repeat the picture. Returning to the image on the groundglass after each two-shot sequence, I repositioned the camera to conform to the grease-pencil sketch and double-exposed the sequence six more times, all at the same exposure. I then had one sheet processed normal as a test. After carefully examining this film, I had the other sheets pushed to a 1/2 stop. This made the blur more brilliant and increased the contrast in the overall image. Because each sheet was slightly different, the best picture was a subjective decision.

The charm of the blur effect is that subjects respond differently to this treatment. Be sure to plan blur shots thoroughly, and have plenty of Polaroid film on hand. This will make mastering the technique easier. Once you have the right tools, all you need is the imagination to dream up an appropriate and compelling subject.

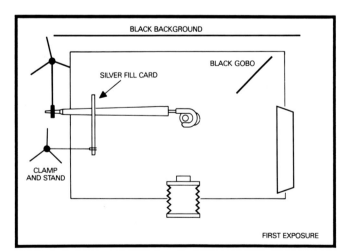

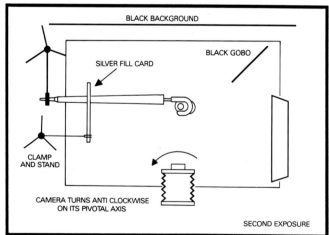

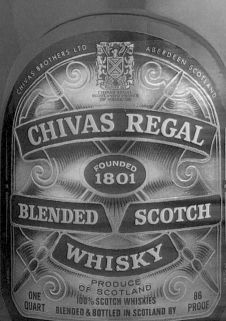

SHOOTING ON LOCATION

Photographers, by definition, are voyeurs. We are always looking for photographic opportunities. I find that what I see in real life often triggers ideas for still lifes. Unfortunately, much of what I see remains only a mental picture. This closeup shot of a café was a happy exception. I had traveled to a small, sleepy fishing village on the west coast of Majorca for a 10-day vacation, bringing with me a Nikon 35mm camera, a few lenses, a lightweight tripod, and some color Fujichrome 50 daylight-balanced film.

As soon as I arrived on the island, I began to appreciate the wonderful local color of Majorca, Spain. The children splashing in the Mediterranean Sea, the fragrant olive groves, the fishermen with their day's catch—all combined to create a storybook atmosphere. I was inspired to capture Majorca's charm on film. This photograph of a café shows a typical lunch scene, complete with white wine, salad, olives, and bread, and provides a glimpse of life in a tropical climate. The figure's relaxed position as he lingers over a Winston cigarette exemplifies the low-key Spanish atmosphere. I wanted to arrange a through-the-lens image that would simplify the elements, thereby creating a poster-like image. The difficulty I had, as photographer, was to work quickly enough to unite the man and the food and drink in one strong composition.

Fortunately, after days of observing café life, all the visual elements came together in my mind—and in front of me as I prepared to record the moment.

It was almost 3 o'clock, and most of the lunch crowd had moved on. I was sitting at the table next to this one, discreetly watching the scene and preparing for the right moment. Shooting with a Nikkormat EL camera, a Nikkor 85mm lens, and Fujichrome 50 daylight-balanced film, I set the aperture at $f/5.6$ in order to throw the background completely out of focus. Next, I preset the distance at 10 feet so that when the time was right, I would be able to quickly fine-focus on the wine bottle. With the camera set on the "autoexposure" mode, the metering system favored the highlights of the picture, silhouetting the figure and saturating the spotty sunlight that filtered through a bamboo roof and fell on the table. I wanted the center of attention to be the wine bottle, partially hidden in shadow. Because Fujichrome 50 is a medium-contrast, high-resolution film, it held the shadow detail brilliantly. Luckily, before the man moved out of frame, I was able to fire off three exposures. The autoexposure feature on the Nikkormat EL is quite reliable. I keep a fresh battery in the camera at all times so that it reads light levels at peak capacity. Periodically, I test the camera to reacquaint myself with its autoexposure capabilities and to ensure that the system is working properly.

When I returned to my studio, I duped a 5 x 7 enlargement of one of the 35mm images for my portfolio. I then placed the original in my file of travel locations, and *Islands* magazine requested it for an essay on life in Majorca.

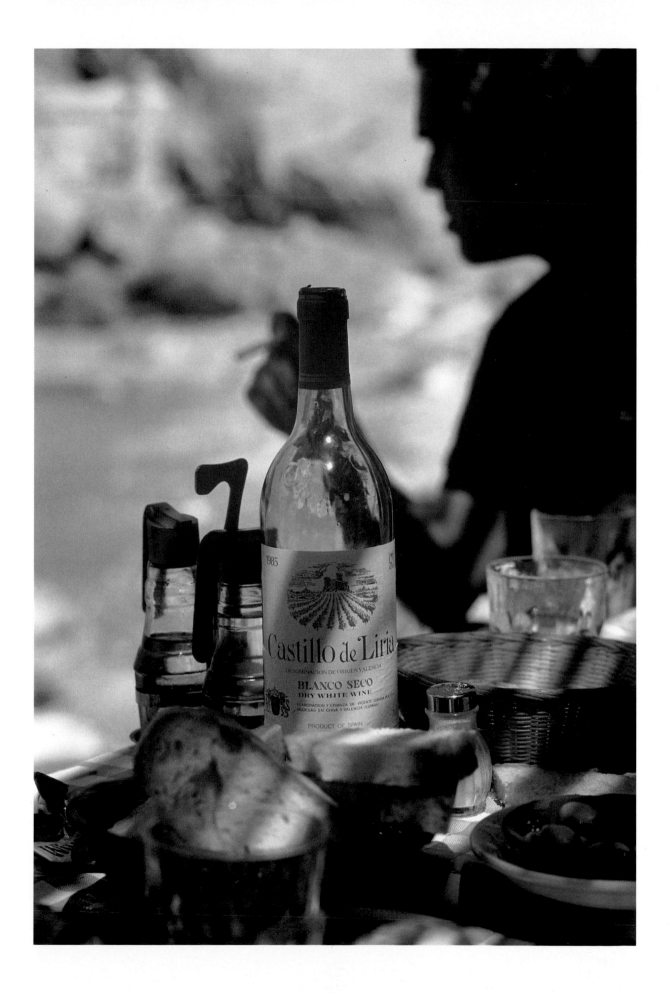

PART THREE
FOOD

HOW TO SHOOT AND STYLE APPEALING IMAGES

Food photography can provide the bread-and-butter accounts of a still-life photographer's business. The strong interest in food and gourmet cooking has resulted in a rash of publications devoted exclusively to them and, in turn, many outlets for fresh, exciting photography. In addition, the steady stream of new products and the attendant advertising require innovative photography for both packaging and marketing needs.

Isolating a single element as the key to successful food photography is a difficult process. A sound grasp of composition is critical, as is technical competence for accurately capturing color. Even slightly off-color food is unappetizing. You also have to learn certain tricks of the trade in your career, such as making a viewer imagine what a steaming bowl of soup smells and tastes like or how crunchy a particular type of cracker is. The whole point of food photography is to appeal to the viewer's palate. Perhaps one of the most important elements is your ability to establish a network of talented food and prop stylists whose work you know. The caliber of their input often determines the quality of your final image. Even with the support of a strong team, however, you are ultimately responsible for the shoot's success.

Magazines often commission still-life photographers to create illustrations for recipes and for articles on gift ideas and food trends, as I was for the Mother's Day shot shown here. Food editors and art directors sometimes have specific, predetermined ideas and only a vague concept at other times. In the latter case, you must be able to determine the essence of the article and come up with an appropriate illustration. If the magazine does not provide you with a food and prop stylist for these assignments, it is critical that you use talented, professional freelancers. Both types of stylists have to be skilled at selecting attractive-looking food and proper glasses, tableware, and linens. Although any wine glass might do to an undiscriminating viewer, the vineyard owner whose Bordeaux is being featured in an article would cringe at the sight of an inappropriate glass in the accompanying photograph. Hire only excellent food and prop stylists you can rely on and trust.

Food stylists are skilled in the culinary arts. Their invaluable creativity and imagination establish a visually compelling display. They are often called both to prepare specific dishes and to develop recipes that are photogenic to be used on the product's packaging. Good food stylists are also familiar with all of the problems that can occur when delicacies

are photographed. They are masters of making foods appear fresh and appealing on the set; for example, they know just how to put perfect grill marks on a steak and garnish it delectably. Finally, food stylists arrive at the studio equipped with a complete selection of state-of-the-art cutlery gadgets, and can use them to peel off the thinnest lemon skin, scallop potatoes, or finely slice vegetables and cheese.

Prop stylists, on the other hand, are valued for their elegant tastes and well-established networks. Skilled prop stylists also maintain Rolodex files filled with the names of sources for unusual items, everything from old, wire-rimmed glasses to antique cobalt dishware. Essentially professional shoppers, these individuals can field any request and produce a number of choices.

Some stylists do the entire presentation: the shopping, the cooking, the propping, and the styling. This type of stylist is particularly helpful when you are working with a tight budget or are preparing a self-promotional piece and must absorb all of the costs. Other stylists are experts in specific areas, such as regional cooking or elegant styling. Again, you must give some thought to which stylist is best, weighing your choice against your photographic objectives and budget constraints.

Unlike food photography for editorial work, food shots for advertising are generally assigned by ad agencies, although some food manufacturers have in-house staff members who work directly with freelance photographers. More so than editorial clients, advertising agencies usually have a specific concept in mind, which obviously focuses on the product. So the pressure is on you to create a strong, single image that enhances the client's product. In addition, these assignments call for you to consider the ideas of not only the food and prop stylists, but the art directors and account executives as well.

Food photography also requires a comprehensive working knowledge of various lighting effects. One editorial spread, for example, might require soft, diffused morning light for the opening picture and candlelight for the final shot. Because most food photography is done in the controlled environment of a studio setting, you can utilize the full range of lighting techniques and special effects.

Your choice of camera will have a great impact on your still-life photographs. The large format of a 4 x 5 view camera allows tremendous control of composition. It is also well suited to shooting a stationary

subject and producing a high-quality image with optimum detail. In addition, the variety of optics available can readily help you to create different moods. Although the view camera seems cumbersome and intimidating, the difference in quality between the 35mm and 4 x 5 formats is incomparable, and a mastery of the view camera will reward you with a reputation for excellence.

After choosing your equipment, you will compose and determine camera angle with mock-ups of the food: it inevitably melts or wilts under hot studio lights. To avoid this disaster, skilled food stylists automatically set up a dummy dish to use for test shots and time the food to be finished when the photographer is actually ready to shoot. Black-and-white Polaroid film (Type 52) is ideal for tests to check composition, exposure, and lighting effects. Its highlight and shadow details resemble Ektachrome 64 film's response. While making test shots is a mainstay of all professional photography, it is particularly important in photographing food: by testing, you can limit the costs of food ingredients, preparation, and stylists.

Although food photography is usually done in the studio, location shooting is sometimes a better solution. The spontaneity of on-location work is often charming. But you must be prepared for any eventuality to prevent disastrous surprises. My trusty travel ensemble includes a portable strobe system made up of four Norman 200B packs, diffusers, filters, silks, and a 35mm camera. I use the 35mm format when shooting on location because it provides the necessary mobility. Building an inventory of location possibilities that you can draw upon is also important. Some of the most interesting spots turn up on a vacation, a family picnic, or a walk in the woods.

Finally, keep up with current trends in food photography. For example, how does the photography in gourmet-food magazines differ from that in mass-oriented women's magazines? You will find that certain approaches run in cycles. For example, with the advent of nouvelle cuisine, food photographs were stripped down, containing only key elements accented by only dramatic but sparse props—quite a departure from the cluttered compositions favored earlier. Depending on the image's subject and purpose, both approaches can be effective. Successful food photographers capitalize on current trends, improving and refining them whenever possible, and anticipate future trends.

SHOOTING TO A CLIENT'S SPECIFICATIONS

This image was part of a 12-picture series that was to be bound and inserted into national magazines for Food & Wines from France, an importing firm. Carla Capalbo, the food and prop stylist, and Jane Rubini, the art director for TBWA Advertising, Inc., spent weeks developing recipes that would complement and enhance the appeal of the wines featured in the insert. Capalbo and Rubini gave the client close to 30 recipes, from which it chose 12. The food stylist then put together a prop list for each approved recipe and discussed these with the client, which had specific ideas in mind. Because the food had to complement the wines, both the props and the set had to be authentic and elegant. The Bordeaux wine required the appropriate glass; an all-purpose wine glass would not do.

Once the visual impressions created by the props involved with the assignment satisfied everyone, we were able to proceed. By grouping similar shots, we were able to adhere to the shooting schedule— which is essential when there are time and budget constraints—by producing two pictures a day. The morning shots called for desserts or cold dishes that had been prepared the night before. The afternoon shots usually were reserved for hot dishes that had been prepared at the studio that day. While the recipes were being tested, I experimented with ways to establish a lighting pattern and a consistent camera angle that would work for the entire series. The basic set was simple: a flat surface covered with a tablecloth, and an unobtrusive background made out of a sheet of silk-screened paper. A bank light equipped with a Speedotron strobe head served as the key light. I placed fill cards on both sides of the bank light to control highlights and contrast.

My next concern was the positioning of my Sinar 4 x 5 view camera. In order to establish a sense of depth in the wine glass, I chose a high camera angle. Using a lens with a long focal length was critical to the visual strength of the photograph: it would compress the compositional elements, bringing the foreground and background closer together visually. This type of lens would also enable me to tilt the lens board to achieve increased depth of field. I selected a Schneider Repro-Claron 300mm lens because of the additional coverage it provides on a 4 x 5 view camera when extreme swings or tilts are necessary. Confident in my choices, assistant Ken Maguire and I were ready to begin shooting. When I photographed this image of a pear, cookies, and a glass filled with white wine, I exposed six frames of Ektachrome 64 daylight-balanced film for 1/60 sec. at $f/32$. One sheet was processed normal; I held the rest in reserve in case any adjustments were required. Once I evaluated the first sheet of film, I knew that we were on target. I then had the lab process two other sheets normal and the remaining sheets at 1/4-stop push. The push-processed film gained contrast slightly and was my prime choice for the final photograph.

Still-life photographers must not only be organized and technically proficient and innovative, they must also have a competent and creative team to work with. Because of this team's expertise and input, I was able to photograph some recipes twice, after changing the props to alter the mood of the image. The entire series of photographs, including small shots of the wine bottles for product identification, took about two weeks to prep and another two weeks to shoot.

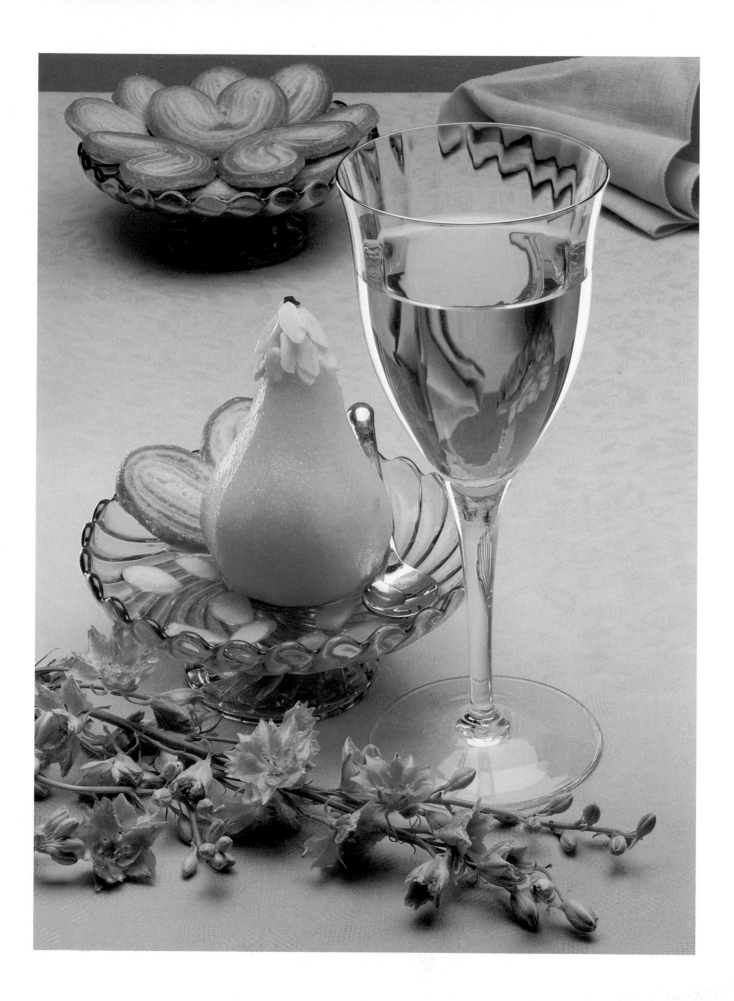

THE BENEFITS OF TESTING

Although cameras, lights, and backdrops are critical to the successful creation of a photograph, I think that no piece of equipment is more important than a good lens. This photograph was made as a lens test. I purchased a used Schneider Symmar 240mm *f*/5.6 lens from a retired studio photographer, who had acquired the lens while on assignment at the Schneider factory in Germany. Company technicians had hand-selected and bench-tested the lens, and earmarked it for exceptional sharpness. I knew that if my test results met my standards, this lens would become a workhorse in my studio.

I began with an infinity shot for overall corner-to-corner sharpness. This checked out perfectly. Next, I wanted to shoot an effective closeup studio composition that would prove the lens' sharpness, depth, color, clarity, and contrast. Deciding that an elegant place setting with a beautiful dessert arrangement incorporated all these elements, I called Carla Capalbo, an expert food stylist, and asked her to create a dessert that would include a range of primary colors; a pastry shell, to provide texture; and a sauce, to provide contrast and reflections. We also discussed the types of plates, flatware, tablecloths, and napkins that would establish an elegant atmosphere.

After Capalbo and I scheduled the test for an entire day's shoot the following week, she proceeded to send props and equipment necessary for the shoot to my studio via messengers. On the morning of the shoot, Capalbo arrived with raspberries flown in from Israel, kiwis, strawberries, grapes, melon balls, and extravagant pastries. She then spread them out on separate cutting boards and together we selected the best specimens. After placing the linen and plate on the set, Capalbo put together a *hiro,* a dummy dish for lighting tests.

I began setting up the lighting equipment. For the key light, I positioned a medium-size strobe bank light above the set, at an opposite angle to the camera in order to maximize the reflection on the sauce. Next, I aimed another strobe, equipped with an optical snout, directly at the fruit to ensure maximum color fidelity. From the right side, I placed a direct strobe at the table level to spread across the cloth, creating sharp lighting for crisp texture. Finally, I added a mirror to throw light onto the grapes in the bowl; this illumination drew attention to the edge of the composition, without detracting from it.

At this point, Capalbo had arranged the dessert plate and switched it with the hiro. As I viewed the composition through the groundglass, she made final adjustments and carefully spooned on the sauce. I refocused and shot a final 8 x 10 color Polaroid (Type 809). After examining the Polaroid and making minor adjustments to the fork and napkin, I exposed six sheets of Ektachrome 64 daylight-balanced film for 1/60 sec. at *f*/32. I processed one normal, reviewed this sheet, and then had the balance processed at a range of densities: two at 1/4-stop push, two at 1/3-stop push, and another one normal.

This Schneider lens more than met my highest expectations and proved to be a wise investment. In addition, Capalbo and I established a mutually beneficial working relationship. She provided me with an elegantly styled dessert for testing and portfolio purposes, and I provided her with a welcome addition to her own portfolio.

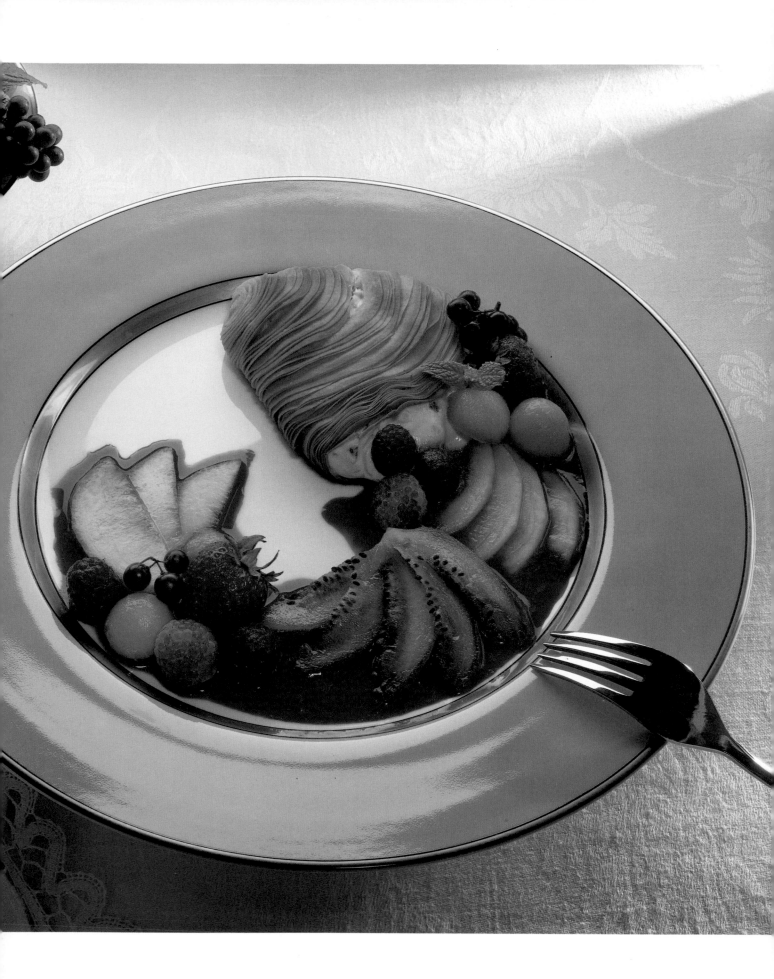

WAITING FOR THE PERFECT NATURAL LIGHT

As a professional still-life photographer, I know that developing my creativity by experimenting with my own picture ideas is important. A welcome bonus is being able to add new material to my portfolio. This photograph of a springtime setting was just that: an on-location, still-life test shot. After seeing these apple blossoms, I realized that they would make a perfect frame for still-life compositions. But heavy spring rains caused the blossoms to fall and forced me to postpone shooting the image I envisioned until the following year. This gave me ample time to think about the picture and to watch the sun to determine the best time of day to shoot. I wanted a simple, natural image: no strobe lights, no tungsten lights, just available light.

While brainstorming, I always consider the feasibility and the budget of an experimental photograph. On the day I had chosen for the shoot, the weather was beautiful and the apple blossoms were in full bloom. Conveniently, the location of this shot was my backyard. All of the props came from my kitchen cabinets and drawers. My wife assisted me by acting as a stylist. Together, we selected the bowls, plates, wine glasses, pitcher, utensils, food, and wine. My wife then sliced the cantaloupe, kiwis, and strawberries; decorated the pie with the strawberries; arranged the fruits; set the table; and chilled the wine.

With the set ready, all I had to do was wait for the proper lighting. In the spring, the setting sun pours into my backyard through an air shaft, spotlighting the apple blossom tree around 6 P.M. As the sun continues to set, the surrounding row houses at the far end of the air shaft act like a natural funnel for the direct sunlight, feathering it off the table and highlighting the apple blossoms. I determined that the lighting was absolutely perfect by 7 P.M.

Having already decided to shoot from the vantage of the second-floor bathroom window, I had mounted a Hasselblad camera with an 80mm lens and a right-angle accessory viewfinder onto a heavy Gitzo tripod, equipped with a crossbar. I looked down and framed the picture with the apple blossoms. As I observed the image in the groundglass, I asked my wife to help me orient the composition by moving the table and chairs into the appropriate corner. I also directed her to make some final adjustments to the food. Then I made some test Polaroids (Type 669, ISO 80), shooting swiftly before the sun set.

Satisfied with these results, I switched to Fujichrome 50 daylight-balanced film. I knew that its warm tones, sharpness, and exposure latitude were ideal for reproducing the table detail with full clarity in a medium-long shot. Aware that the setting sun would allow me only a few moments to record the scene, I worked quickly. I monitored the exposure with a Minolta Spot Meter from the camera angle. I shot the final prime transparency between f/22 and f/16 for 1 sec., at exactly 7 P.M.

As the client, art director, and photographer of this inviting photograph of an informal table filled with desserts, I was satisfied with my efforts. This picture, which for a long time remained only in my imagination, proved successful both as a self-promotion mailer and a portfolio piece.

FULFILLING EDITORIAL REQUIREMENTS

Magazines commonly hire still-life photographers to create generic pictures that introduce articles featuring, for example, recipes and gift ideas. This shot of a lavish breakfast tray was used to suggest Mother's Day for a May issue of *Romance Today* magazine. After meeting with art director Bob Kirk, I understood the need for a tight, intimate shot. The magazine's food editor then explained that the breakfast must include an omelette and fruit. Although these parameters were previously established, Carla Capalbo, the food stylist, enjoyed a fair amount of creative license. On the day of the actual shoot, she carefully prepared a sumptuous omelette, champagne, strawberries, muffins, and coffee. Denise Rowley, the prop stylist, assembled an elegant place setting, complete with fine china and roses.

My task was to meet the editorial requirements. Using a mock up of the breakfast tray, I determined composition, camera angle, and lighting. Shooting from high above the set with a Sinar 4 x 5 view camera equipped with a Schneider Symmar 210mm lens, I made sure that I left ample space below the tray for the article's headline. Next, I placed a venetian blind to the left of the set and, behind the blind, a 2,400 watt-second Speedotron strobe head with a 12-inch reflector turned on at full power. Aiming this light directly at the tray, I adjusted the blind to create shadows and highlights that would simulate daylight coming in through a window. I then mounted a medium-size Chimera bank light, equipped with a 2,400 watt-second Speedotron head set at 800 watt-seconds, on a boom and positioned it over the tray. This produced a gentle fill light, opening up the shadows on the tray. The direct light behind the blind established the image's mood, while the bank light provided shadow detail and color saturation.

With the lighting equipment ready, I ran some Polaroid tests. The hiros were then replaced with the styled food, and I made one last Polaroid test to verify composition and lighting. Satisfied with the result, I shot six frames at a basic exposure of 1/60 sec. at *f*/22 on Ektachrome 64 daylight-balanced film. For each shot, the food stylist poured fresh champagne into the glasses in order to maximize the bubble effect. And, because I used strobe rather than hot lighting, the food stayed fresh for the entire shoot.

Later, I sent one sheet of 4 x 5 film to be processed normal. It proved to be perfectly balanced, so I requested normal processing for the remaining five sheets. Of the six frames exposed, the image shown here best combined the proper styling, ambience, and effervescence.

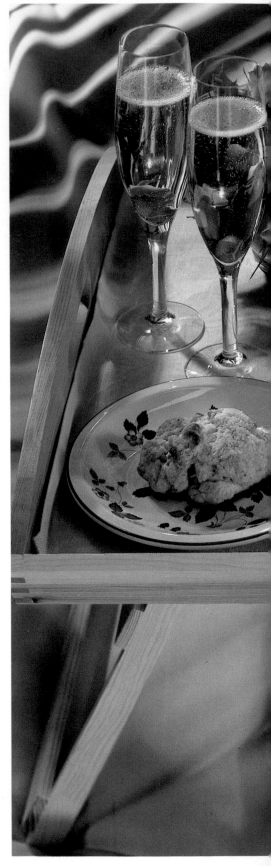

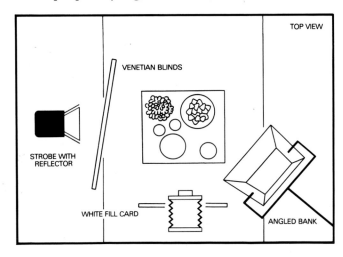

TOP VIEW

VENETIAN BLINDS

STROBE WITH REFLECTOR

WHITE FILL CARD

ANGLED BANK

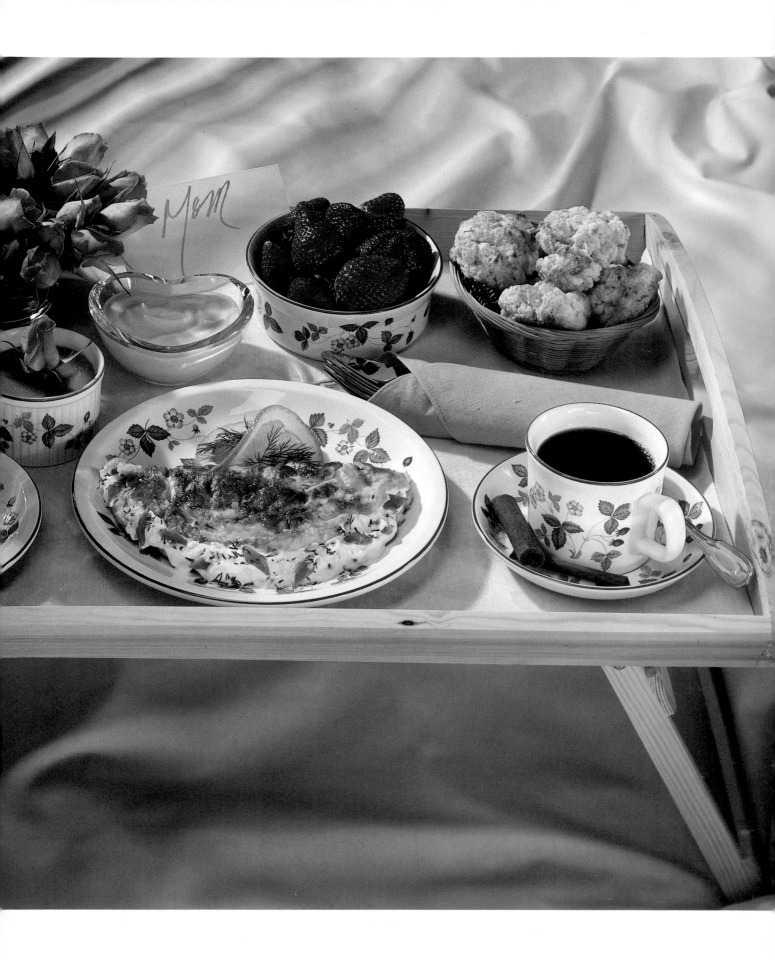

THE PRODUCT SHOT

When Borden introduced Krisp & Natural crackers, a new product manufactured by the company's Old London division, I was hired to devise a strong look for the advertising campaign. Michael Parmen, the creative director assigned to this account at Jordan, Case, McGrath, Borden's advertising agency, had purposely developed a familiar concept: it both featured the box and product and showed serving suggestions. As a result, I was free to experiment with the camera angle, lens choice, and lighting for the image.

During a preproduction meeting, Parmen and I discussed the color of the set first. We determined that it should enhance the product and the package design. Ideally, we wanted a warm tone, light enough to display the product in the foreground but dark enough to accommodate a drop-out headline in the background. I suggested Varitone, a resin-coated, air-brushed paper that ranges in color from light to dark and comes in two sizes: small measures 12 x 24 inches; large measures 30 x 48 inches. A large sheet was perfect for this product shot.

The art director also indicated that he wanted to use smoked salmon, salami, and jam as the toppings for the crackers. So on the morning of the shoot, food stylist Carla Capalbo purchased these items and arrived at my studio with them, as well as various garnishes. But when Capalbo laid out the food, the smoked salmon looked too pale when placed alongside the dark-red strawberry jam. Luckily, Capalbo was able to quickly contact three local specialty shops and send messengers to pick up more—and pinker—salmon. She then proceeded to prepare two other crackers, spreading jam on one and placing salami and lettuce on the other. When the new salmon arrived, she arranged a piece on a cracker, increasing its sheen and deepening its color by brushing the salmon with a thin coat of vegetable oil. Capalbo made four more of each combination—just in case. Finally, she arranged the three best crackers, propping up each one on a wooden cutting board with a small, clear Plexiglas support, which was about 1/4-inch thick and the size of a quarter.

I decided to use a Sinar 4 x 5 view camera and a Schneider Super Angulon 90mm lens in order to produce a bold, eye-catching illustration. Standing close to the set, I used the camera's front and back standards to correct the keystone effect caused by the wide-angle perspective. I then swung the back standard slightly to increase the size of the box in the image. For the lighting pattern, I chose a medium-size Chimera bank light with a Speedotron head as the key light, placing it above the set and just out of the picture frame. This arrangement established strong overall lighting with ample shine on the food. Next, I added silver fill cards to reflect light onto the front and sides of the box. Also, because wide-angle lenses often cause flare, I used black cards as gobos to block any stray light.

Now ready to make some test shots with Polaroid film (Type 52), I stopped down the lens to f/45 for maximum depth of field and determined that two strobe pops were needed to build up a prime exposure. I then had Ken Maguire, my assistant, load four holders with Ektachrome 64 daylight-balanced film and began shooting the final exposure. I bracketed at two, three, and four pops (all processed normal), and one pop (pushed a full stop). The shoot took one full day. But my efforts were rewarded: Borden was quite pleased with the images and immediately approved the advertisement.

CONSTRUCTING AN APPROPRIATE SET

Product fact sheets and point-of-purchase displays often rely on strong photographic illustration to sell products. To promote its imported French cheese, Besnier needed a single eye-catching image that showed its entire product line and at the same time conveyed a French flavor. I decided to break away from both the cold, slick advertising shots that the client was accustomed to and the standard product shots used for in-house purposes. A set evoking Provence seemed to be the perfect natural stage for displaying the different cheeses because of their ornate labels and wooden boxes. The set I envisioned offered warmth and authenticity

The set construction, which was expertly done by assistant Ken Maguire, entailed building a single wall with a window. Off-white paint was diluted with a sand mix to add a rough texture to the wall, suggesting an old house. Six 12-inch stained pine planks were joined to form a harvest table. Stylist Carla Capalbo kept the props, such as the wine glass and the bread and cheese knives, to a minimum. Rather than drawing attention away from the cheese, they served as visual devices to unite the product with the environment. As such, the props reinforced the provincial French atmosphere.

My next task was to ensure that the cheeses would be displayed to their best advantage. The print medium demands that a package's shape, label, and logo be clearly legible and free of distortion. Also, the product's color and texture must be accurate. (Dulling spray can be used to eliminate a particularly stubborn reflection, but I find that it alters the color density and texture of a package label.) To meet these requirements, I carefully manipulated my lighting pattern and camera angle.

Here, I used three separate lighting sources. The key light was a direct Speedotron strobe head with a 6-inch reflector, set at full power (2,400 watt-seconds) and mounted on the side and to the right of the camera. Raking across the wall, this light brought out the texture of the painted surface and provided a shadow. The second light source was a medium-size Chimera bank light with a Speedotron strobe head. This light was mounted on a Bogen boom, positioned above the cheese, and adjusted to 1,200 watt-seconds. Its function was to illuminate the pack-

age labels and to fill the shadows created by the direct side light. The third light, a Speedotron head with a 12-inch reflector set at 1,200 watt-seconds, was placed behind the window and bounced onto a white flat to reflect light through the curtains.

To complete the lighting setup, Maguire added silver fill cards to open up the shadows around the cutting board. Finally, he mounted small, black flags above certain reflective parts of the package labels to control flare on the logo. At this point, I critically focused my Sinar 4 × 5 view camera with a Schneider Symmar 210mm lens while standing on a ladder. After shooting 20 Polaroids (Type 52, ISO 400) and making numerous product and lighting adjustments, I was ready to expose the image on Ektachrome 64 daylight-balanced film at four strobe pops at $f/64$ for maximum depth of field.

I find that every shoot is a learning experience, whether it be by trial and error or by someone passing on information. In this case, the client sprinkled the round face of the white-skinned cheese with baby powder in order to improve its reproduction quality. This was a little trick he picked up while on a shoot in Paris. (However, it is best to check local consumer regulations before utilizing these special food-enhancing techniques.) The resulting image, which took an entire day to shoot, was well received by Besnier representatives both in France and New York City, and has been used repeatedly for advertising and promotion.

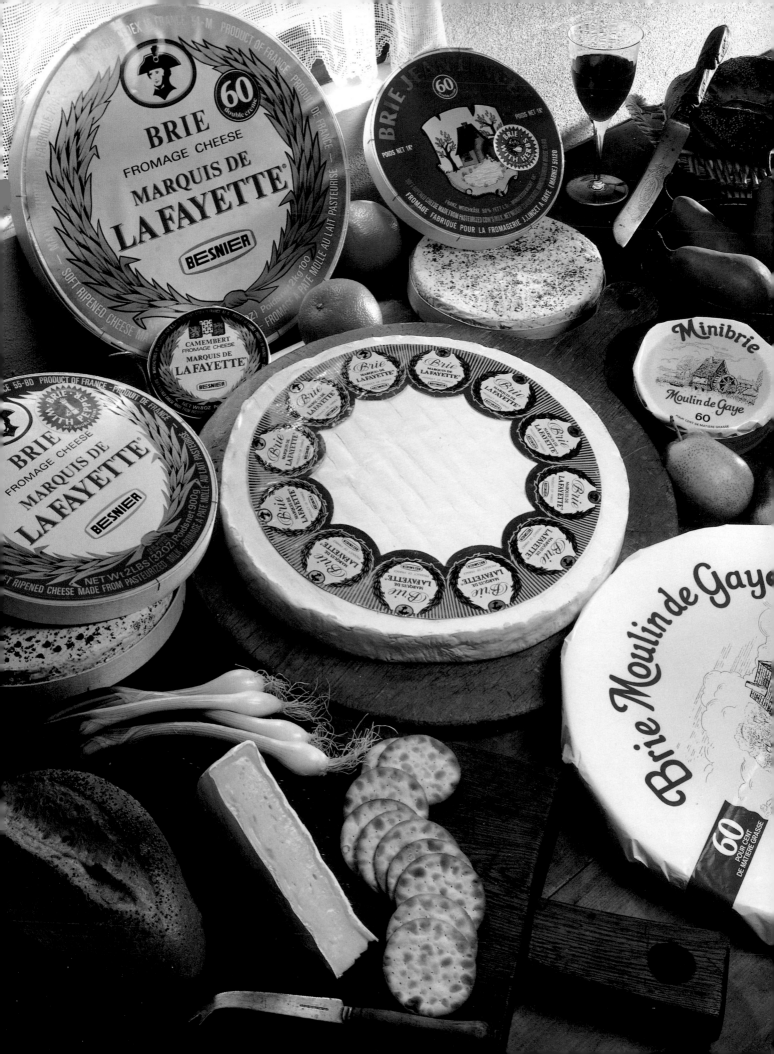

THE IMPORTANCE OF PREPRODUCTION PLANNING

When TBWA Advertising, Inc., approached me to shoot Frobel's Laughing Cow cheese products for a three-panel spread, I faced a challenge. I had to devise a way to photograph dozens of different bite-size morsels of cheese, crackers, crudités, fruit, and other hors d'oeuvres in a single image before the cheese melted—or the studio crew ate the props. During the preproduction meeting, art director Jane Rubini described a lightbox effect that would graphically outline the cheeses and other snacks. After Carla Capalbo, an expert food stylist, examined the Frobel product line, she suggested various fruits and vegetables suitable for this approach. Capalbo then set out to create approximately 50 tidbits that would showcase the cheeses. By the day of the shoot, she had succeeded. She arrived at the studio with her newly sharpened Hoffritz knife, which she used to slice the food as thinly as possible; we wanted them to appear translucent on the "lightbox" set.

To create this effect, I had purchased a 20 x 30-inch piece of milk white Plexiglas, which I would illuminate from below, as the background surface. Next, I devised a small, black frame whose opening had the two folds marked with string and conformed to the proportions of the layout. This enabled Capalbo to set up the cheese hors d'oeuvres so that they would not fall into the folds of the image in the final brochure. Although she experimented for more than half a day to find the right arrangement, almost all the food held up for the duration of the shoot. At this point, while Capalbo held her breath, my assistant and I carefully and gently placed the Plexiglas "platter" on two sawhorses.

My next task was to decide which equipment to use. Because this image had so many elements and so much detail, it required a large format. I chose my Sinar 8 x 10 view camera with a Schneider Symmar 240mm lens and suspended the camera from a Bogen heavy-duty camera stand, centering it over the set. Then, to illuminate the food from below, I placed two Speedotron heads on the floor and directed them up through the Plexiglas. I plugged both heads into a 2,400 watt-second Speedotron power pack and set each head at 1,200 watt-seconds. I added two 8-inch reflectors, covered with Lumilux, a diffusing material, to spread the light evenly. The first Polaroid test that I made showed the silhouette effect I had envisioned. But, not wanting the food to appear completely silhouetted, I used a Chimera bank light with a Speedotron head above the set and adjusted to 800 watt-seconds. I positioned it relatively low and slightly off-center. This provided a gentle fill light that opened up the shadows; as a result, the food itself would stand out.

To check that the lighting ratio was correct, I made a few more 8 x 10 color Polaroid (Type 807) tests. These indicated an excellent balance. Then, after Capalbo moved a few hors d'oeuvres and replaced wilting garnishes with fresh ones, I made a final Polaroid test to verify a perfect composition.

Ready to begin photographing, I switched to Ektachrome 64 daylight-balanced film and shot for 1/60 sec. at f/22, bracketing 1/2 stops in either direction. The six exposures I made may seem like a small number of film sheets to use for a major assignment, but the time and effort spent on preproduction planning eliminate unnecessary—and wasteful—shooting later. A final point to keep in mind: Leave the set intact until you see the processed film and are satisfied with the results.

THE BEAUTY OF A NATURAL SETTING

After steadily photographing products in my studio for an extended period, I often feel the need to shoot on location. I have found that breaking out of the predictable studio surroundings and routine is critical from time to time. Because I am limited to only the bare essentials in terms of equipment, shooting outside the studio sharpens my instincts. In addition, I always seem to come across unusual environments when I travel. While I was on a vacation on Majorca, Spain, the quality of light and the unique aspects of the location inspired me. Throughout the trip, I looked for situations that I could transform into strong images, which I would be able to use for stock sales to travel magazines and book publishers. This sixteenth-century grotto proved to be perfect.

I traveled light as I explored Majorca, equipped with only a shoulder bag filled with Nikon 35mm equipment. As such, I knew that any photograph I made would have to be simple, utilizing existing light and readily available items. Wanting to feature local produce in a natural setting, I asked a longtime family friend for permission to photograph her traditional Majorcan house. With her assistance, I collected the necessary props from her kitchen: a ceramic bowl, a wood cutting board and a knife, and a wine decanter and glasses. Once we had assembled these items, we set out for the village to shop at the local market for cheese, fruit, bread, and wine.

Returning to my friend's house, we went directly to the backyard grotto, which provided a beautiful natural setting for a provincial food shot. We poured the wine, sliced the cheese and the figs, and arranged the other fruit. Then I realized that I needed a bridge to match the bottom part of the frame with the top. I glanced around the backyard, looking for something that would enhance the composition. I quickly found the perfect accent. With the addition of some bright purple flowers picked from the footpath leading up to the grotto, the set was complete.

Using a Nikon F2 camera mounted on a tripod and a Nikkor 24mm lens, I composed a wide-angle image, maximizing depth of field. Photographing at a slow shutter speed enabled me to capture the movement of the water and to create an interesting effect on the floating petals. I shot one roll of Fujichrome 50 film, varying the composition slightly and bracketing the exposure. The most aesthetically pleasing image turned out to be a slow exposure: 1/2 sec. at f/11. When I saw the processed film, I was quite satisfied with its ability to hold highlight detail, as well as its color saturation.

Although I could have attempted to re-create this classic grotto in my New York City studio, achieving a comparable combination of natural light and natural setting would have been quite uninspiring. Conceptualizing and executing this photograph created both a pleasant, memorable morning during my Majorcan vacation and an easily marketable image as a generic stock food shot—as I discovered when *Islands* magazine requested the picture.

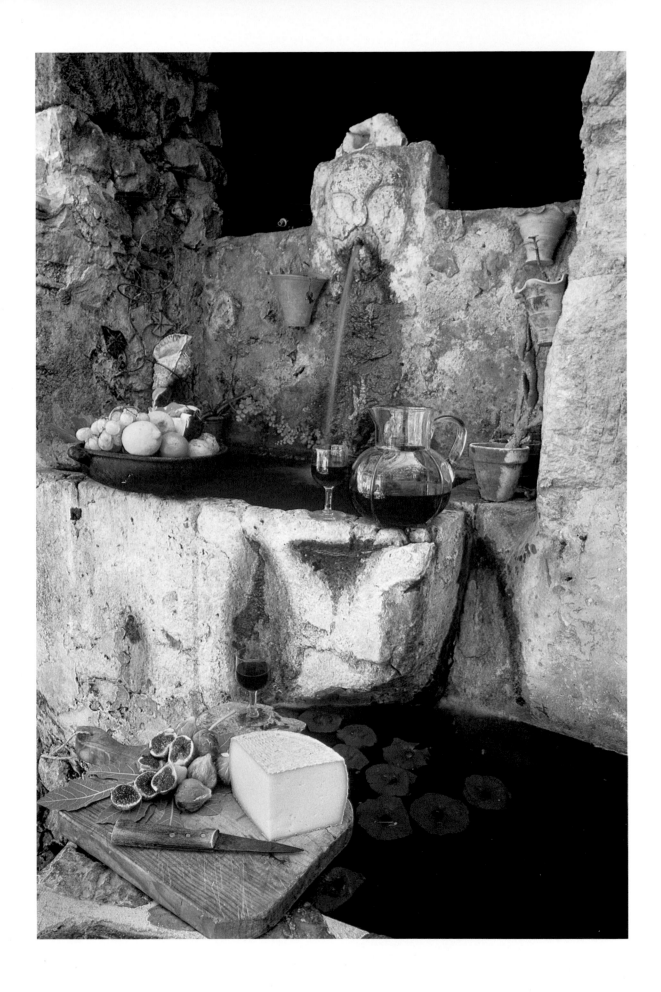

MEETING A TIGHT DEADLINE

For a special section on health and fitness for the Sunday *New York Times,* the editors decided—the afternoon before a 9 A.M. color deadline the next day—to accompany an article on the advantages of a low-fat diet with an illustration of fresh fruits and vegetables. Hired to provide this photograph on an overnight basis, I discussed the assignment over the telephone with the editors and the writer of the article. We agreed that a tight, poster-like closeup would be ideal because the space allotted for the shot was half a page. The writer then explained which types of produce would be most appropriate.

With no time to organize a team of stylists and assistants, I ran out to Balducci's, an upscale food market, to collect the props before the store closed. Because color and texture are the critical elements in closeup shots of food, I needed to buy at least five or six specimens of each fruit and vegetable that I had decided upon. I actually began composing the picture in the store's produce aisles: I picked out some less-than-perfect samples to contrast with the flawless appearance of others.

Back at my studio, I called an assistant, who agreed to come in and work throughout the night. First, we assembled a simple set, which consisted of a 4 x 6-foot sheet of white, 3/4-inch-thick foamcore placed on the studio floor and tilted upward, toward the spot where the camera lens would be. Then, keeping in mind the requirements for a tight shot, we arranged the produce at the corners of the set, working toward the center. I was careful to select various complementary colors, shapes, and textures as I composed. For example, my assistant and I placed the brown, oval, and rough walnuts near the white-and-brown, circular, and smooth mushrooms. And, to add an element of freshness, we moistened the grapes using a plant sprayer.

Next, we positioned a medium-size bank light with one strobe head slightly below the horizon line of the image area. The illumination from the bank light wrapped around the food, producing broad highlights and deep shadows for a wonderfully rich cast. We then hung a Sinar 4 x 5 view camera overhead on a camera stand. This type of support enabled me to shoot down at the set with much ease and stability. The Symmar 210mm lens I used provided a pleasing visual effect. With a white fill card positioned at the front of the camera, I gently reflected light into the shadows to complete the lighting pattern. Polaroid (Type 52, ISO 400) film established that the basic exposure was two pops at f/32 on Ektachrome 64 daylight-balanced film. I bracketed in 1/2-stop increments by altering the strobe output, while increasing the number of pops.

After staying up half the night shooting, my assistant dropped the exposed film, marked "Rush," in the lab's night box. Our efforts were well rewarded: we had created a variety of arrangements for the editors to choose from, and were able to hand-deliver the film to the anxious editors by 9 A.M. They were delighted with the images —and thrilled that they would meet their deadline.

CREATING A MOOD

This tantalizing soup was photographed for *Romance Today,* a glossy, monthly consumer magazine. In order to help me prepare for this particular shot, Bob Kirk, the magazine's art director, sent me the article that would accompany the image. He also explained that the shot of the soup would run as a double-page, opening spread. Keeping this parameter in mind as I read the text, I began to come up with various concepts for the shot. During the preproduction meeting, I discussed these ideas with Kirk and Denise Rowley, the magazine's prop stylist. The three of us first agreed that the mood of the photograph should be warm and elegant, and then discussed the specific props needed to create this mood.

On the day of the shoot, Rowley brought a large variety of copper soup tureens, lace tablecloths and napkins, spoons and bowls, and candlesticks, and spread everything out on a table for easy selection. As she began to arrange the set, we decided to include oil and vinegar cruets and a bunch of roses. At the same time, the magazine's food editor was cooking the soup, following the recipe faithfully. Minor creative changes could be made in the final preparation only, such as adding zucchini slices as a garnish.

While the set and food were being prepared, I started thinking about the lighting. I wanted a sharp, direct light source to produce a shadowy background. I positioned the key light, a Speedotron head with a medium-spot grid attachment, to the side of the set and aimed it directly at the spot where the soup tureen would be; I then set the head at 1,600 watt-seconds. Next, I hung a large bank light with one Speedotron head above the set. I adjusted this head to 400 watt-seconds, so that it would act as a soft fill light for the foreground only. Finally, I aimed another Speedotron head, equipped with a small optical snoot also set at 400 watt-seconds, on the area where the "steam" from the hot soup would rise. (All three Speedotron heads were powered by one 2,400 watt-second power pack.)

Next, working from a high angle, I composed the image through a Schneider Symmar 210mm lens, mounted on a Sinar 4 x 5 view camera. I used an acetate mask that indicated both the gutter of the magazine spread and the sides of the image on the groundglass in order to ensure that the composition would properly enlarge to scale. My final preparation involved test shots. I used black-and-white Polaroid film (Type 52, ISO 400) slowed down to ISO 64 with a neutral-density .80 filter to check the basic exposure of 1/60 sec. at *f*/32 and to fine-tune the composition. I then switched to Ektachrome 64 daylight-balanced film for its reproduction quality and excellent contrast.

When the composition completely satisfied me and the prepared soup was in place, my assistant blew smoke through a straw to create the effect of steam. I shot eight frames, all at the basic exposure. The "steam" added an unknown element because I had no idea how it would look in the final image. As a result, I needed extra backup frames to provide us with options. I made one sheet a control frame and had it processed normal. I held the other film back in case any adjustments were needed. But when I checked the first sheet, I decided to process the others normal as well. Kirk was pleased with the results and subsequently assigned me to all of his food shots. I enjoyed all of the *Romance Today* shoots because of the dynamic that evolved between the magazine's crew and myself.

JEWELRY

HOW TO CAPTURE DETAIL ELEGANTLY

When photographing jewelry and gems, I treat the pieces as works of art. This approach applies to catalog work, editorial assignments, and museum documentation. The objective is to showcase the jewelry and to clearly convey a sense of quality, no matter how costly or inexpensive the piece is. Interestingly enough, the skills and techniques needed to shoot costume jewelry are also required to capture the nuances of a rare, gold museum piece.

The main challenge every photographer faces when working with jewelry is to control the inevitable highlights and reflections. Whether the pieces are made of gold, silver, brass, chrome, or tin, the lighting problems are similar. After extensive experimentation, I have come to rely primarily on two methods of lighting jewelry: broad bank lighting and the use of a constructed diffusion tent. I prefer to work with a medium-size Chimera bank light when illuminating small objects: I can lower it on a boom, bringing it as close to the object as possible and just out of the frame. This provides long, well-defined highlights. The other approach calls, of course, for diffusing materials, such as silks and Lumilux. These are perfect for constructing a continuous, seam-free, soft illumination. When you shoot from directly above the set, you can arrange the tent so that it surrounds the object on four sides. When the best angle is a straight-on view, you can either devise a three-sided tent or cut a hole in a four-sided tent to allow space for the camera lens.

Another challenge jewelry photography poses is capturing the beauty of different stones: rubies, diamonds, turquoise, sapphires, and emeralds. Some gems, such as rubies and turquoise, soak up light. Others, including diamonds, reflect light. To counter the light-absorbing quality of dark stones, use a direct light source. This can be a single-source spotlight, which I used for the ruby shown in this section, or reflected light from a mirrored surface. Diamonds, real or fake, require an overall diffused light to eliminate harsh reflections. However, adding a well-placed spotlight provides a single, dramatic glint that enhances rather than detracts from the gem. Practice until you discover lighting patterns that please you—and flatter the gems.

Shooting highly reflective objects, such as a polished silver brooch, also calls for specific equipment to facilitate the elimination of all possible reflections. For this reason, whether you work in the 35mm or 4 x 5 format, shooting with a long lens is preferable. Long lenses place the

camera farther away from the subject, reducing the size of the reflection. Macro lenses have become the jewelry photographer's standard because they enlarge fine details, such as engraving and gem facets. Also, the inherent clarity of macro lenses ensures remarkably sharp images. I find the Schneider Repro-Claron lens to be an excellent companion for both 4 x 5 and 8 x 10 view cameras. When I shoot with a Hasselblad camera, I use a 120mm lens, often combining it with Hasselblad Proxar lenses. For my Nikon 35mm camera, the 105mm Micro-Nikkor lens is perfect. Experiment to see what works best for you.

Like other photographic specialties, shooting jewelry requires certain techniques. First, you have to scrupulously clean the jewelry with professional materials. Always be sure to handle precious pieces with clean, white cotton gloves. Next, equipped with both ingenuity and improvisational skills, you will not have to rely on expensive props. To help balance and support a delicate piece, you can build an armature out of inexpensive sculpture wire to fit any shape. This eliminates searching special display shops or hiring set designers. Affixing jewelry to the armature or background can be accomplished with beeswax.

Choosing an appropriate background is essential for jewelry photography. The various background surfaces available in art-supply stores include multicolor pebbleboards, Varitone paper, and, of course, seamless. Do not let the huge selection intimidate you; persevere until you find the background that works best with a particular piece. Another option is to break out of the mold. Consider fabrics and ordinary household items, such as printed sheets, crumpled aluminum foil, and

brick walls. A setup does not have to be complicated, however. Sometimes a stark image is effective, particularly when the jewelry's design is strong. Once again, the solution is experimentation.

The last creative choice you must make involves your approach. You can shoot a conceptual image, such as the bird's nest shot shown here, or a more straightforward one, such as the shot of three watches. Conceptual photographs dramatize objects in an unexpected way and help keep both your mind and your eye sharp. In a world saturated with images, the ability to produce inventive photographs is essential and marketable. While finding new ways to visualize familiar objects and perfecting the techniques to execute them are important, you are always in danger of forcing a concept. The result may be stiff, inappropriate, and unbelievable—quite the opposite of the desired effect. Simple, beautifully illuminated pictures can be the ideal solution when clarity is critical. You must evaluate each assignment individually to determine the best way to approach it. I find that if a concept does not come naturally, I aim for a classically elegant image and allow the lighting and composition to carry the visual message.

A final point about photographing jewelry: you must always take security precautions. Although most companies maintain insurance coverage for their merchandise and often provide a security guard for particularly rare pieces, you should get adequate insurance if photographing jewelry becomes a regular part of your business. Remember, you are working with valuable pieces and are ultimately responsible for their safekeeping.

A SUCCESSFUL PROMOTIONAL IMAGE

Stephen Maron, a French-Canadian jewelry designer, asked me to photograph this ring, his most prized piece. He had traveled to New York City to offer the Museum of Modern Art to make a limited edition of the ring to be sold in its gift shop. Because of my having successfully completed several assignments for the museum, it recommended that Maron contact me for a series of pictures to promote the ring. During our meeting, I suggested that we imitate a pedestal used for displaying art because his intention was to appeal to the museum's audience. I also felt that a hand was the natural stage for the ring. Maron loved this innovative approach immediately.

Finding the perfect hand model was easier than I had anticipated. The day after my meeting with the designer, I attended a cocktail party. As I shook hands with another guest, I knew that I had discovered the ideal candidate. I hired him on the spot. His hand would work well with the ring because of its dark skin tone and slim size. We discussed the assignment in detail and, because the man was new to the modeling business, I asked him to have a manicure on the day of the shoot.

The session proceeded smoothly. Maron joined Carol Hess, my assistant, and myself as we began to design the "props." He helped to ensure that the ring was displayed and illuminated to its best advantage—and to his satisfaction. The challenge was to provide a comfortable, steady support for the model's arm and hand. Utilizing an old crutch that we had padded for extra comfort and had adjusted to the proper height for the model's arm, we were able to position him comfortably on the set. We experimented with various hand poses, and Maron selected those that enhanced his ring's design.

Next, I determined the lighting pattern. I wanted a broad, diffused, single light source to create detailed highlights and soft shadows. This would juxtapose the texture of the hand and the smoothness of the ring. To achieve this effect, I used an overhead bank light with a Speedotron head set at its full power of 2,400 watt-seconds. And, by adding two small, white fill cards, I was able to reflect light onto the ring to accentuate the gold tone, as well as to produce a pool of light in the palm of the model's hand. This gave the shot extra dimension.

Just about ready to shoot the ring, I decided to use a Hasselblad camera with a 120mm lens, stopping way down to $f/16$ for maximum depth of field. The first test I made with Polaroid film (Type 665) was overexposed by a full stop, so I reduced the key light's power to 1,200 watt-seconds. The second Polaroid test was perfect. Nevertheless, when I switched to Ektachrome 64 daylight-balanced film, I bracketed the exposure, as is my habit. I spent an hour experimenting with different angles and hand positions. For each variation, I adjusted the key light and the white cards slightly in order to maximize the reflection on the gold, made a Polaroid test to check both the lighting and the composition, and then shot the final image.

In the end, the retail price of Maron's ring proved too expensive for the museum gift shop. But the designer's trip to New York City was not a loss: the brochure we produced enabled him to successfully market the ring in Canada.

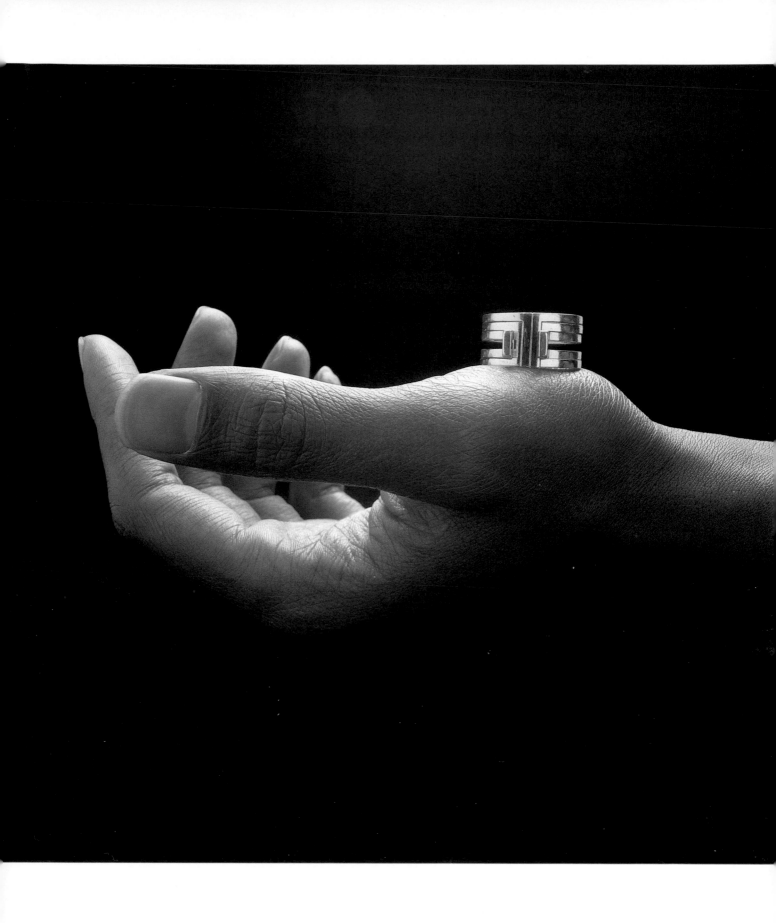

DETERMINING A COMPLICATED LIGHTING PATTERN

Tree Communications, a New York City–based book packager specializing in art books, hired me to travel to India to photograph rare art objects and jewels for *Treasures of the Maharajahs*. Little did I know the extensive preparations this "dream" assignment would entail: weeks of assembling and testing equipment, organizing travel plans, and securing various insurance policies preceded my departure. Because this assignment would require jumping from one palace location to another, I had to devise a reliable, mobile "studio" that could be easily broken down, packed, and reassembled. I opted for an extensive Nikon 35mm outfit, two Balcar variable-voltage 2,400 watt-second strobes, stands, tripods, booms, umbrellas, backdrops, fill cards, mirrors, and versatile Kodachrome 64 color film.

Photographing this incredible seventeenth-century ruby—which was the size of a tangerine—was part of my shooting script on this trip. My earlier experience with photographing gems taught me that rubies—unlike diamonds, which reflect light—absorb light. As a result, they have an inner glow when photographed properly. First, seeking to establish scale, I placed the gem on an 11 × 14 sheet of black foil. The abstract reflection of the ruby on this shiny surface gave the object immediate size definition and a strong visual stage. Then, to create the bright, fiery-red glow, I positioned a Balcar strobe head, set at 2,400 watt-seconds, high and behind the ruby. I then put a snoot over the strobe head and aimed the light directly at the gem.

Another important part of the lighting setup involved highlighting the inscription on the top of the ruby. To achieve this effect, I positioned a medium-size Chimera bank light equipped with a Balcar strobe head set at 800 watt-seconds above the gem. I used a Nikon F2 35mm camera, a Micro-Nikkor 55mm lens, and Kodachrome 64 film. I determined the basic exposure with a Minolta flash meter, arriving at f/16 for 1/60 sec. I exposed an entire roll of film, bracketing the exposure and altering the strobe power ratio for different effects.

On photo assignments in the Third World, working under primitive conditions—and extreme pressure—is normal, and processing film is impossible. There is only one chance to shoot a complicated closeup perfectly. To reduce photographic risks, it is necessary to shoot a great deal of film. Bracketing exposures by at least one full f-stop in either direction from the basic exposure and shooting a few extra basic exposures are essential.

Photographing such a unique gem was a once-in-a-lifetime experience. Because this photograph is the only contact most people will ever have with the ruby, I thought it was particularly important to capture its essence. The response this image receives makes me feel confident that I succeeded.

ENHANCING A UNIQUE DESIGN

Laurie Winfrey, the picture editor at *Connoisseur* magazine, assigned me to shoot the jewelry designs of innovative designer Fulco di Verdura. Gracing common objects found in nature with precious gems is Verdura's trademark. Winfrey wanted still-life photographs of some of the designer's most exquisite pieces to accompany an article about him. Interestingly, what made this assignment particularly challenging was the human element. Many of the Verdura pieces belonged to individuals who were scattered throughout New York City. I needed to be quite diplomatic when attempting to convince the owners to lend me their jewelry.

The first piece of jewelry I photographed for this assignment was a 1950s scallop shell adorned with diamond and turquoise stones. Because Rene Schumacher, the art director at *Connoisseur,* had given me carte blanche to experiment with various interpretations, I was able to be creative in my approach. I decided to use different surfaces to enhance the unique characteristics of each design. For this piece, I decided on a shiny, black pebbleboard (which is available in any art-supply store) to create a reflective environment that suggests water. Using this surface enabled me to reflect the aqua-blue color onto the background—an essential effect for the look I wanted to achieve.

The next task was to securely place the scallop shell on the pebbleboard. Always conscious of the priceless nature of the piece, I knew that it had to be mounted carefully. Because there were no props involved in this particular shot, a stylist was unnecessary. So Carol Hess, my assistant, built a small armature according to my specifications. She shaped the support out of sculpture wire to match the size of the shell exactly; this held the scallop shell safely in an upright position throughout the shoot.

Setting up the lighting equipment followed. I used a Chimera bank light with a Speedotron head set at half power (1,200 watt-seconds). The illumination from this light raked across the shell's surface from the left side, accentuating the fan-like effect of the ribs. I then placed a fill card on the right-hand side to open up the shadows and to establish the foreground reflection on the pebbleboard. With the object light, I created the background glow by placing a Speedotron head set at 1,200 watt-seconds with a small snoot and a blue gel behind the shell, slightly higher than the camera lens, and carefully aimed it to reflect light onto the black pebbleboard near the lower edge of the shell. Finally ready to shoot, I positioned my Hasselblad camera with a 120mm lens and made some black-and-white Polaroid tests (Type 665, ISO 80) to check the lighting balance. Next, I adjusted the position of the background light and exposed Ektachrome 64 daylight-balanced film for 1/60 sec. at f/16. I shot a full range of bracketed exposures at 1/2-stop increments because I knew that reshoots were impossible.

This assignment entailed three weeks of extensive preproduction work: tracking down the owners, obtaining their permission to photograph the jewelry, and coordinating their schedules with mine. Then, once I had the scallop shell in my hands, conceptualizing, lighting, and completing the photograph took an entire day. And, because the piece was available only for the day for photography, I had to shoot many different setups. Of all the backgrounds I used, the shiny, black pebbleboard—my first choice— proved to be the most effective. In fact, this photograph was used as the lead picture for the magazine article. Based on the success of both this image and the rest of the pictures for the Verdura shoot, I became a regular contributor to *Connoisseur.*

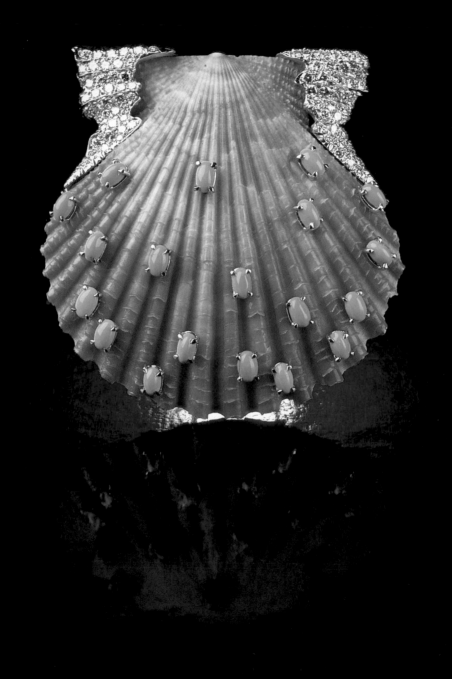

EXECUTING AN IMAGINATIVE CONCEPT

While it is important to master a number of photographic techniques, they are frequently useless unless the photographer can also visualize a picture long before exposing the film. This ability to conceptualize an image is highly valued by art directors and clients because it involves creativity and often problem-solving. To demonstrate my own skills, I wanted to shoot a self-promotion piece that would both feature a product and utilize an imaginative approach.

I thought that using a classic, old-fashioned pocket watch offered wonderful possibilities for dramatizing such "time-honored" expressions as "Time waits for no one" and "The test of time." I decided to use the small, articulated figures available in art-supply stores with the watch. Although the figures are abstract, they represented people caught up in a time struggle perfectly. Making the leap from the mental image to the tabletop arrangement was easy. For the somewhat surrealistic effect I wanted, black "slate" Formica, available in 4 × 8-foot sheets, proved ideal: its ridges catch light and provide an outerspace look. Then, realizing that I would be shooting at eye level, I knew that I needed to establish a horizon line. I accomplished this with a bright, if somewhat eerie, red light. Turning my attention to the figures made of blond wood, I thought that they were too light. I then spray-painted them to get a black matte finish. After they dried, I experimented with their positions until I found just the right stance. To keep the figures steady, I waxed all of their joints and attached their feet to the slate surface with a hot-glue gun. Next, I joined each figure's hands around the chain and waxed them together. This enabled me to suspend the watch between the figures.

With the stage set for the "tug of time," I began thinking about the lighting pattern. To capture an otherworldly feeling, I placed tungsten mini-spotlights on either side of the figures. These lights created the strong, vertical highlights that silhouetted each figure. I put another mini-spotlight on a boom above the set. It produced the horizontal highlights on the arms and the tops of the figures' heads; this light also picked up the ridges in the Formica, adding an intriguing dimension to the picture. At the same time, these three mini-spotlights fully illuminated the pocket watch. Finally, to achieve the background glow, I placed a single tungsten mini-spotlight at the rear of the set, covered it with a red gel, and aimed it from a low angle at the black seamless in the background.

Wanting to create a wide-angle perspective, I chose a Sinar 4 x 5 view camera because of its performance when combined with a Schneider Super Angulon 90mm lens. Once I composed and focused, I shot lighting tests with Polaroid film (Type 52, ISO 400). I determined the basic exposure to be 8 sec. at $f/32$ on Ektachrome 50 tungsten-balanced film. I bracketed eight sheets at 1/4-stop intervals, ranging from 6 sec. to 12 sec. After the film was processed normal, it was clear that the 8 sec. exposure was still the best.

While it is difficult to measure the sales potential of a promotional effort, this image demonstrated to prospective clients what I hoped was a fresh eye and excellent technical ability. The two days that I devoted to this project were worthwhile: the image elicits favorable responses, in part because of its resemblance to a graphic, eye-catching window display.

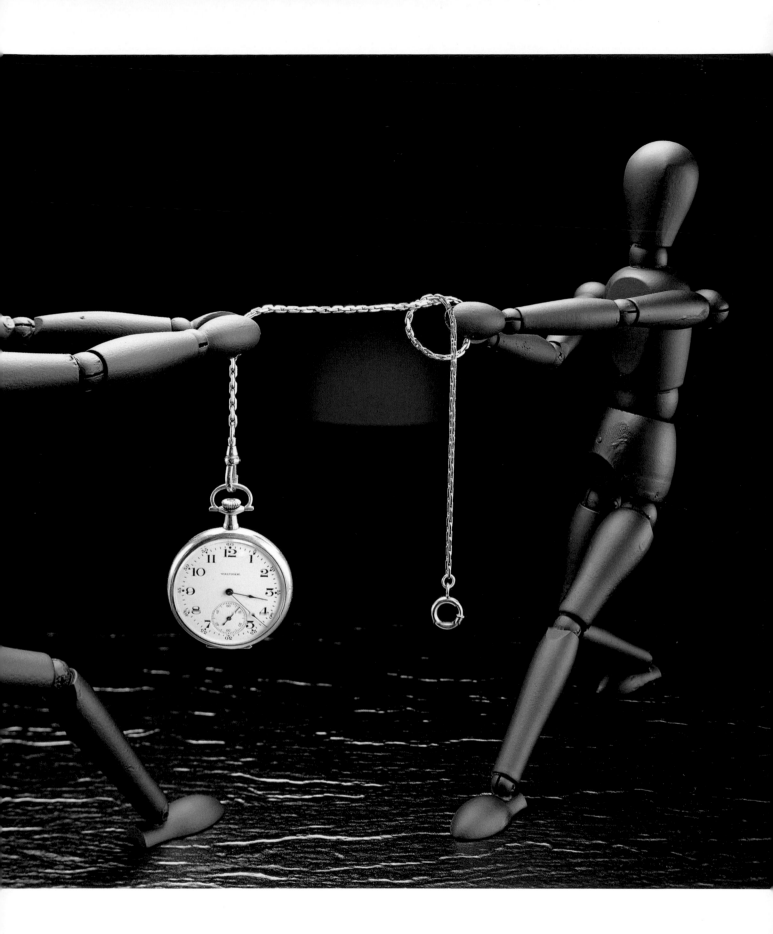

PRODUCING AN EVOCATIVE PHOTOGRAPH

For this editorial shot of antique watches, I wanted to create a sense of place and time. As a result, careful propping was paramount. So I consulted Carla Capalbo, a stylist with a good eye and a knowledge of sources of antiques. Because we were working with small watches, it was important not to overpower them with intrusive props. Together we assembled the key elements, which I ultimately composed in a rather tight shot. A glimpse of a beaded bag, a hint of a textured fabric and fine lace, a necklace of clear beads, a satin ribbon, and the classic paisley box perfectly complemented the watches and helped to establish the idea of old, precious treasures. The soft ivory color of the background provided an effective contrast to the principal subjects.

Setting up the lighting equipment proved to be something of a challenge. For the key light, I used an overhead bank light with a Speedotron head adjusted to 2,400 watt-seconds. Positioning the bank light in order to avoid catching reflections in the glass crystals of the watches was especially tricky. This required me to scrutinize the image on the groundglass to make sure that there were no reflec-tions. Next, I placed a white fill card in the foreground to soften shadows.

The lighting pattern for the shot, however, was not yet complete. One final step was needed to define the detail in the white fabric. I fastened 4 x 5 black-cardboard flags to the end of each of two booms, which were placed between the light source and the set. The flags shaded the light, permitting the fabric's rich texture to show.

Although I would have preferred to shoot this image with a 4 x 5 view camera to achieve superior clarity and detail, budget constraints compelled me to use a Hasselblad 2 1/4 medium-format camera. The exposure was f/16 for 1/60 sec. on Ektachrome 64 daylight-balanced film.

Once the set was styled and illuminated and the composition decided upon, I was able to finish shooting in less than two hours. From an aesthetic point of view, the balance of black and white with just a shot of color was most successful. The photograph also conveys the sense that the watches are precious objects from another era, which was precisely the objective of the *Village Voice*.

CHOOSING THE BEST BACKGROUND

While shooting on location in India for Tree Communication's *Treasures of the Maharajahs,* I faced a technical challenge: photographing a solid gold object with several gemstones and 11 wrists. The statue, a representation of the goddess Chamunda, is a priceless artifact. I photographed this image in my primitive, makeshift, on-location "studio."

Although I had carefully assembled my portable studio back in New York City, I found that spontaneous problem-solving is often necessary when traveling light, without access to suppliers. For this shot, any of the numerous backdrops that I had brought with me would have been acceptable, but none proved to be ideal. This gold art object required a simple yet elegant background. Having to quickly come up with an alternative, I decided to use a royal blue bedsheet, which was provided by the Maharajah. At first, I was grateful that this rich-looking blue linen was available, but I soon became concerned that the fabric's texture would compete with the statue. To resolve this dilemma, I asked an assistant to shake the linen during the time exposure of 6 sec. This eliminated the wrinkles and created an unobtrusive backdrop.

Next, I turned my attention to the lighting-equipment setup. I positioned a medium-size Chimera bank light and a Balcar strobe head set at full power (2,400 watt-seconds) above the object. As a result, the illumination feathered off the background. I carefully placed two small, white cards on either side of the artifact to add tone and modeling to the statue's gold surface. Including the white cards enabled me to create controlled, rather than random and unpredictable, reflections. Finally, I illuminated the background independently with the modeling light of an open Balcar head. This lighting pattern worked perfectly here. It held the detail on the gold's shiny surface and produced saturated color, especially in the gemstones.

After checking the lighting balance with test Polaroids (Type 665), I determined the basic exposure: 6 sec. at *f*/16 on Kodachrome 64. This long exposure was necessary in order to throw the background out of focus as my assistant shook it. Once again, I used a Nikon F2 35mm camera with a Micro-Nikkor 55mm lens.

Because of on-location improvisation, this photograph of Chamunda was strong enough to merit being presented as a full gatefold in the book. Evaluating the specific needs and limitations of every assignment is critical: doing this carefully helps to produce the best photographs possible in any situation.

AN UNUSUAL BUT ORIGINAL APPROACH

This photograph of a tie-clasp-shaped ring was among the series of images I made for *Connoisseur* magazine to accompany an article about jewelry designer Fulco di Verdura. While shooting on location at Verdura's showroom, I came across the designer's original conceptual sketch in a book of drawings and decided to combine the two in a single image. This would produce a striking three-dimensional effect. The simple but elegant design of the tie-clasp ring made it a natural subject for the photograph I had in mind. The art director agreed.

Working with limited equipment on location, I fashioned a small cardboard wedge out of the top flap of a matchbook. This would support the ring in its proper position on the sketch. But because there were multiple drawings on each page of the sketchbook, this was a challenge. I had to place the ring on its corresponding sketch and leave enough space around the ring to show the sketchbook background. Luckily, Verdura's impeccable sense of design and color provided a lovely blue sketch adjacent to that of the tie-clasp ring.

My next consideration was the lighting pattern. I purposely kept it simple by using an overhead Chimera bank light with a Dyna-Lite head set at its full power of 800 watt-seconds. This illuminated both the jewelry and the background. To overcome the problem with reflections, John Bellacosa, my assistant, and I constructed a tent out of a roll of tracing paper (which packs up and travels very easily for location purposes), connected it to lightstands, and wrapped it around three sides of the set. This not only eliminated reflections and acted as fill cards for the bank light, but also made the diamonds sparkle.

At this point, I was ready to begin shooting. I positioned my Hasselblad camera mounted with a 120mm lens just above the top edge of the tent and out of the ring's reflective field. I began running Polaroid tests (Type 665, ISO 80) to check the composition. I was concerned primarily with depth of field. After many focus adjustments, I exposed for 1/60 sec. at *f*/16 on Ektachrome 64 daylight-balanced film. This enabled me to hold sharp focus from the sketch to the ring, while softening the remaining background. At *f*/32, for example, the ring and sketches would have held equally sharp focus, so the ring would not have dominated visually.

Because of the nature of still life photography, it is essential to capture a sense of the subject's unique or distinctive qualities. Here, by introducing surprising yet related elements, I was able to connect the actual ring to its creative origin. This photograph was one of the more memorable images in the Verdura series for *Connoisseur* because it personalized the still-life object.

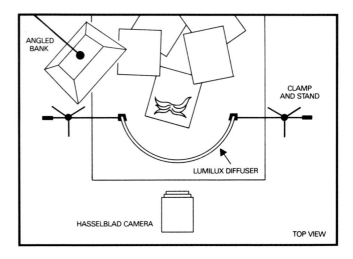

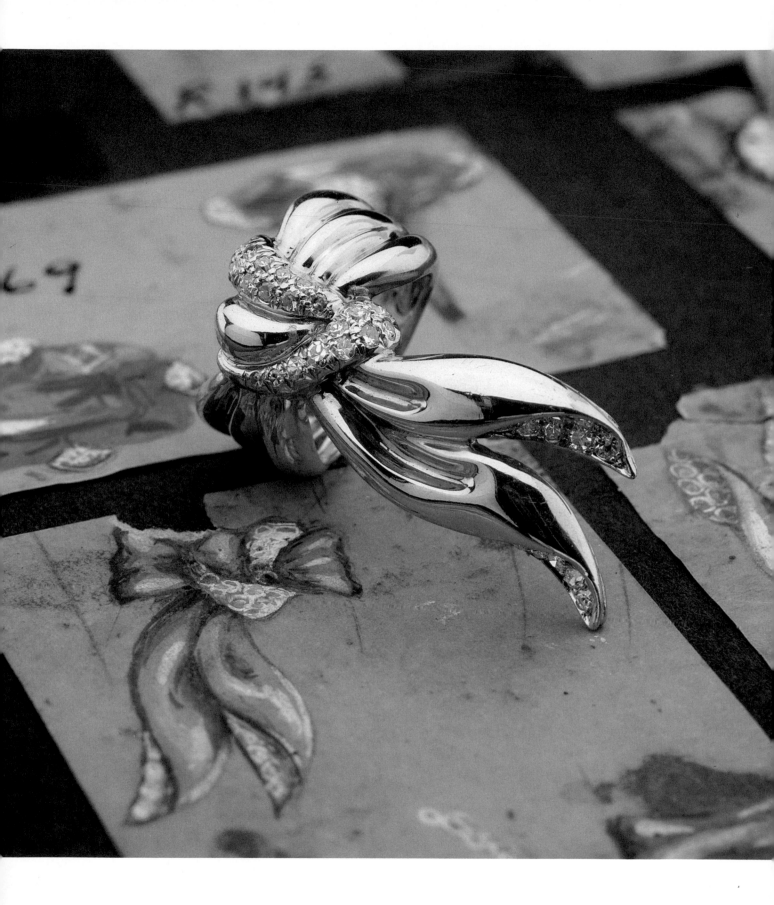

FROM MAGAZINE TO PORTFOLIO

This photograph of the men's accessories was shot for an editorial piece for *Connoisseur* magazine. The original image included the art director's choice of a sky-blue background because it seemed that it would be appropriate for the bird-egg shapes of these mother-of-pearl cuff links. I completed the illustration, adhering to the art director's needs and requests for the full-page layout.

Although the assignment was a success, I was unable to resist the opportunity to reshoot these unique accessories; they were created by Fulco di Verdura, a noted jewelry designer. Because *Connoisseur* and I agreed to one-time North American usage rights, the rights reverted to me after publication. This gave me the freedom to reuse the material as stock photographs, or any other way I wanted to. Of course, I would not be able to publish my reshoot until *Connoisseur's* publication was off the shelves.

Clearly understanding the copyright laws pertaining to this assignment, I began to consider the arrangement and composition of the reshoot. I thought that a bird's nest would be the perfect stage on which to display the shape of the cuff links. Then, during a weekend trip to picturesque Bucks County, Pennsylvania—an area known for its antique shops and artists' colony—I found the perfect nest. Back at my studio, I placed the pieces of jewelry on black felt that I had cut in the shape of the nest. I chose a flat, black background because I realized that the shiny white pearls would separate clearly in sharp contrast to it. And, because the black pearls were iridescent, I knew that they would stand out against the black background, creating a different but equally striking effect.

Pleased with the composition, I proceeded to set up the lighting equipment. The key light was an overhead Chimera bank light with a Speedotron strobe head at its full power of 2,400 watt-seconds. This cast a soft, detailed highlight across the surfaces of the pearls. I photographed the cuff links with a Sinar 8 x 10 view camera with a Schneider Symmar 240mm lens set at *f*/32, using four multiple-strobe pops on Ektachrome 64 daylight-balanced 8 x 10 film. I determined this exposure by making test shots with color Polaroid 8 x 10 film (Type 807). This image required two hours to light, compose, and shoot. By using an editorial assignment as a creative springboard, I was able to transform an otherwise static ensemble into a playful composition—and a portfolio piece that has always been well received.

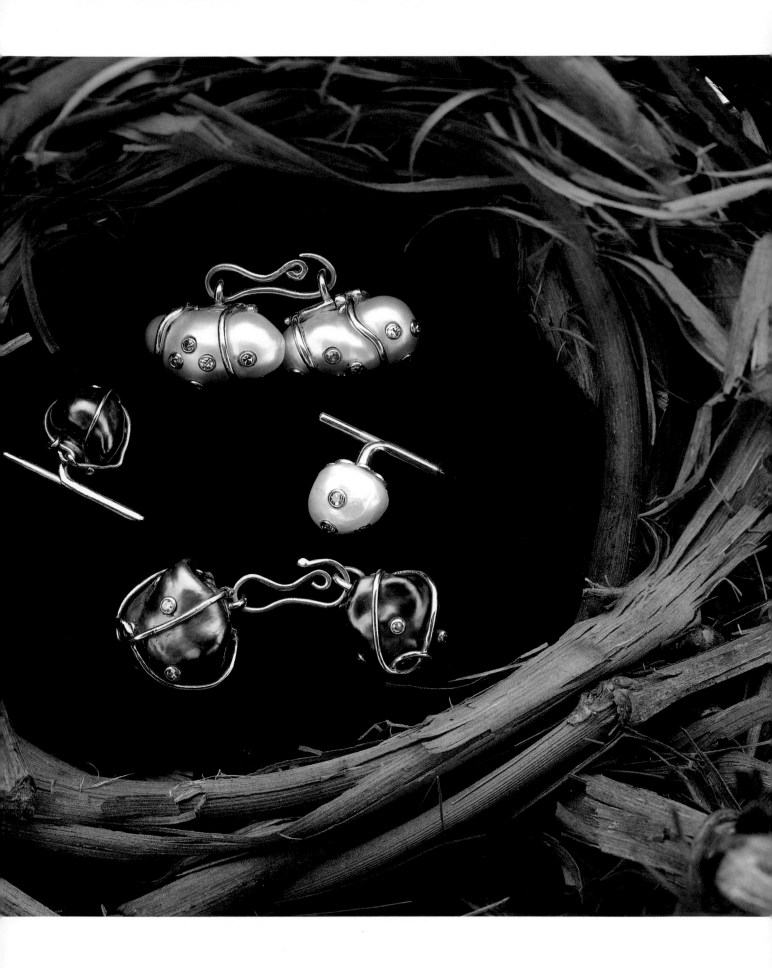

PART FIVE

ART

HOW TO DISPLAY ART AND ARTIFACTS SUCCESSFULLY

Photographing world-famous, irreplaceable art and artifacts is an awe-inspiring task. I have had the privilege of working with pieces that are thousands of years old: observing them closeup, handling them, and photographing them. When shooting art in either my studio or in museums, I often have the support of professionally trained museum art handlers and technical assistants. On other occasions, I have found myself alone working under the most primitive conditions in distant places. But, whether I am shooting on location or in my studio, I know that intense advance preparation is the secret to photographing art effectively.

I start by laying out all of the lighting equipment. I check each spotlight or electronic flash unit for faulty wiring, and then clean it and set it up on a lightstand to make sure that it is in good working order. Next, I strip all odd pieces of tape from the lightstands and tighten screws for rigidity as needed. I then clean the extension cords because they tend to accumulate a great deal of dust and dirt; these wreak havoc with film and lenses. Another part of my preparation is taking my cameras and lenses to the repair shop for a thorough cleaning and adjustment when necessary. I inspect all film holders for light leaks and use a blower brush to remove any dust buildup. Finally, if I am going to shoot on location, I number each packing case and put together an equipment list (including serial numbers) that corresponds to each. This enables me or my assistants to keep track of all of my equipment, which is critical when I travel.

During the photo session, art is rolled in, always well protected and often accompanied by trained art handlers. It is their responsibility to ensure the safety of these valuable pieces, to move them into place, and to stand by in case any adjustments are necessary. While the art handlers unpack the art, your mind is already at work visualizing various possible approaches. Determining the lighting pattern is usually the first major challenge. You can use a single spotlight, an overhead bank light, or natural light, among others; the subject is the dominant controlling factor. For example, the Nefertiti sculpture shown in this section called for a strong overhead spotlight. As I envisioned the pool of light that would result, I knew that this was the right treatment.

Once you establish the lighting setup, you must select the proper background. The environment is an important part of an image's composition so it is essential that you carefully integrate the background

with the lighting and the subject. The backdrop should not be too contrasty or too subtle. The photograph of folk-art fish in a "blue lagoon" demonstrates this type of visual and conceptual harmony perfectly. You will find that once you gain experience shooting a variety of art objects, choosing a background is almost instinctive. To gain confidence initially, experiment with several different colors or textures. I find it helpful to always maintain a large selection of background surfaces in the studio. I instruct my assistants to keep track of this stock of backgrounds and to replenish it when necessary. Transferring backgrounds for a location shoot can, however, be a problem: they are often bulky and difficult to transport. An alternative is to research the availability of materials in the area in which you will be working. If this is not a possibility or proves fruitless, pack wisely and include charges for oversize and overweight baggage in the budget. These can be considerable.

Another basic component of photographing art is mounting the piece. You must safely place the art in front of the camera and position it to achieve the most interesting angle. This can be as simple as placing the object on the set for a frontal view or as complicated as wiring the piece so that it dangles in an unexpected fashion. For some art objects, you may need armatures to provide structure and stability. Once again, experience will teach you which methods to use and when and how to use them. Keeping a toolbox is a must. Assemble a varied selection of saws, blades, screwdrivers, pliers, wrenches, levels, nails, wire, and solvents, among other items. These will often come in handy. For example, a soldering iron can salvage a location shoot when the only lamp burns out. Clearly, photographing art involves more than just a good idea. Trusted assistants provide especially important help. They anticipate your needs and desires: moving the object and adjusting lights, for example. This enables you to stand back and make creative decisions.

If you intend to specialize in shooting art and artifacts, you must become completely familiar with large-format cameras. Although the ultimate large format is 8 x 10, I find that a 4 x 5 view camera works beautifully. It captures a range of fine detail, its vast optic selection makes composition simple, and its size is less cumbersome than that of the 8 x 10 view camera. Furthermore, clients are always pleased with the resulting images because 4 x 5 negatives reproduce so well.

Another effective way to capture extraordinarily fine detail when photographing art is to use flat-field lenses, such as Schneider Repro-Claron lenses. They are available in focal lengths ranging from 55mm to 410mm. I frequently use the 210mm *f*/5.6 lens because it provides a good working distance between the camera and set, has great latitude for swings and tilts, and is easy to shade in the event of flare.

A final consideration is the amount of liberty you take when photographing fine art or artifacts. Although this usually is not much, you can still choose provocative lighting patterns, interesting backgrounds, and unorthodox positioning of the object.

Because curators are understandably concerned about the depiction of art that they have arduously collected for exhibition, you must earn their trust. Once they have confidence in your abilities, you may then discuss interpretive approaches. Remember, however, that your goal is to project the spirit and uniqueness of the piece in the visual image.

By enhancing the fine detail of art and artifacts and making them larger than life, you can compensate for many deficiencies in museum presentation. All too often, poor lighting and dusty cases obscure the beauty of the objects. Moreover, because many people never get to museums or galleries, fine photographs and reproductions are the only way they can see these treasures. As a still-life photographer, you can bring art to such individuals and record its beauty for posterity.

SHOOTING A PRICELESS ART OBJECT

This priceless stone-relief sculpture of Queen Nefertiti dating back to 1355 B.C., was photographed for the cover of the Brooklyn Museum's poster-size art book, *Egyptian Treasures.* Shooting a cover image is always a special challenge. Its visual appeal is integral to the book's sales potential. Also, I had to do justice to this precious art object, one of the many I photographed for the book. I was responsible for preserving the sculpture's integrity while communicating its significance.

Before I even picked up my camera, I had to complete a number of preliminary steps. Advance planning for this on-location shot was essential. First, I assembled the various backgrounds, clamps, tapes, tools, and hardware I might need. I then considered the angle of the shot. A straight-on, eye-level approach was almost dictated by the piece. My next step was to find a way to mount the sculpture without injuring it. Laying it flat and photographing it from above would have resulted in a record shot, not a cover shot. I decided to construct an armature so that I could safely prop up this priceless object. My unorthodox approach is to use a wire hanger; it is strong enough to support most pieces, but flexible enough to bend a number of ways. I do, however, pad the wire wherever it touches any part of the work. Although any nonabrasive material will work, I chose gaffer's tape to protect this piece. Frank Dzebella, my assistant, twisted the wire into the shape of the head and taped the armature in place.

Next, I selected a blue background in order to provide a contrast for the stone's warm tone. Because the sculpture is only 5 inches high, I was able to easily mount it on a 30 x 40-inch sheet of Color Aid, which covered the set table. I then had to anchor the armature from below. I simply pushed the wire through the paper where it could not be seen and taped it to foamcore underneath.

Once I was satisfied that the sculpture was secure, I turned to the lighting. A single, 200 watt-second tungsten spotlight with a small snoot, positioned overhead on a boom stand and aimed directly at the set, provided all the illumination needed. The spotlight created a sunlight shadow and defined the eye, the ear, and the distinctive cheek that art historians find especially entrancing. Any additional light would have washed out these significant elements; any less would have diminished them.

I used a Sinar 4 x 5 view camera and a Schneider Symmar 210mm lens. As I composed at eye level, I left ample space at the top of the film to accommodate type. I made four black-and-white Polaroid (Type 52, ISO 400) tests to check that the lighting and exposure were right. Switching to Ektachrome 50 tungsten-balanced film, I exposed at *f*/22 for 8 sec., and then bracketed at 1/4-stop increments.

After completing this shot, I knew that all the photographic elements needed for a powerful cover image had come together. I immediately called Nai Chang, the head of design at Harry N. Abrams, Inc., (the book's publisher) and conveyed my excitement. When I delivered the film, he created a dummy test cover with a repro-quality C-print and press type. The positive reaction to Chang's presentation at both Abrams and the museum was unanimous. My first book contract was a big success.

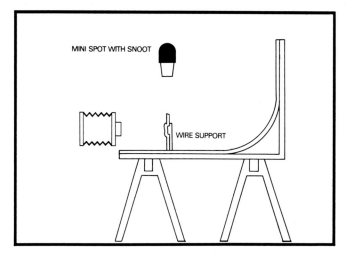

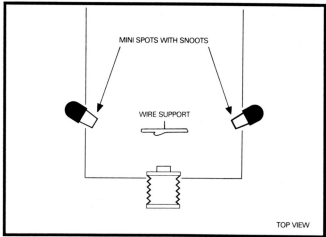

OVERCOMING TIME AND LIGHT CONSTRAINTS

This photograph was made during a trip to Sian, China, arranged by the Metropolitan Museum of Art (New York City) in cooperation with the Chinese Cultural Relics Bureau. The museum needed approximately 150 color plates for the catalog, trade book, and promotional material accompanying a traveling exhibition of rare Chinese artifacts, called "The Great Bronze Age of China." To prepare for this important project, I spent a week at the museum testing lighting patterns on its collection of bronze and terra-cotta Chinese objects. I proceeded to assemble quite an elaborate equipment list, including two complete Sinar 4 x 5 view-camera outfits, 35mm gear, film, hot lights, Variac transformers, volt meters, seamless, Color Aid, foamcore, a portable heater, and a stereocassette player. I shipped all of this equipment in advance in eight huge, wooden crates.

I arrived at the excavation site in Sian knowing that the Chinese Cultural Relics Bureau had limited my shooting time to 15 minutes. I also knew that all shots would have to be captured quickly with available light without a tripod, so I was equipped with Ektachrome 400 high-speed color film. I carried only a shoulder bag filled with two Nikon 35mm cameras and two fast lenses: a Nikkor 85mm f/1.4 lens and a Nikkor 24mm f/2.8 lens. Bringing these two lenses enabled me to shoot intimate views of the site and to obtain the fastest shutter speed possible.

Luckily, the Chinese had built an enormous Quonset-hut type of structure out of a translucent material. This protected the site and permitted excavators to work in every kind of weather. The "hut" also created a diffused light that I realized would translate well on Ektachrome 400 film. At this film speed, my exposures averaged 1/30 sec. at maximum aperture.

Composition was dictated by the excavation site itself: workers were juxtaposed with newly uncovered figures, combining natural verticals and horizontals. Everywhere I turned, another Chinese archaeologist was sifting through earth, finding bits and pieces of terra-cotta soldiers. Incredible images presented themselves all around me. To capture them, I put my camera strap around my neck and took up the slack by wrapping the strap around each wrist. I then tightly pressed the viewfinder against my eye for maximum rigidity. This allowed me to achieve critical sharpness while shooting wide open at slow speeds.

Before leaving for China, I had made a reciprocal arrangement with the museum that would benefit both parties in terms of publicity. So as soon as I returned, I showed *Smithsonian* magazine my picture selects from 12 weeks of shooting. The magazine was quite receptive to the opportunity to publish such unique material. Aware of the historical ramifications of the museum's blockbuster exhibition and the images I was making available to them, *Smithsonian* ran two consecutive covers and devoted many editorial pages to the pictures in each issue. The museum was ecstatic about the advance publicity, and I was elated by the space the magazine gave to my photographs.

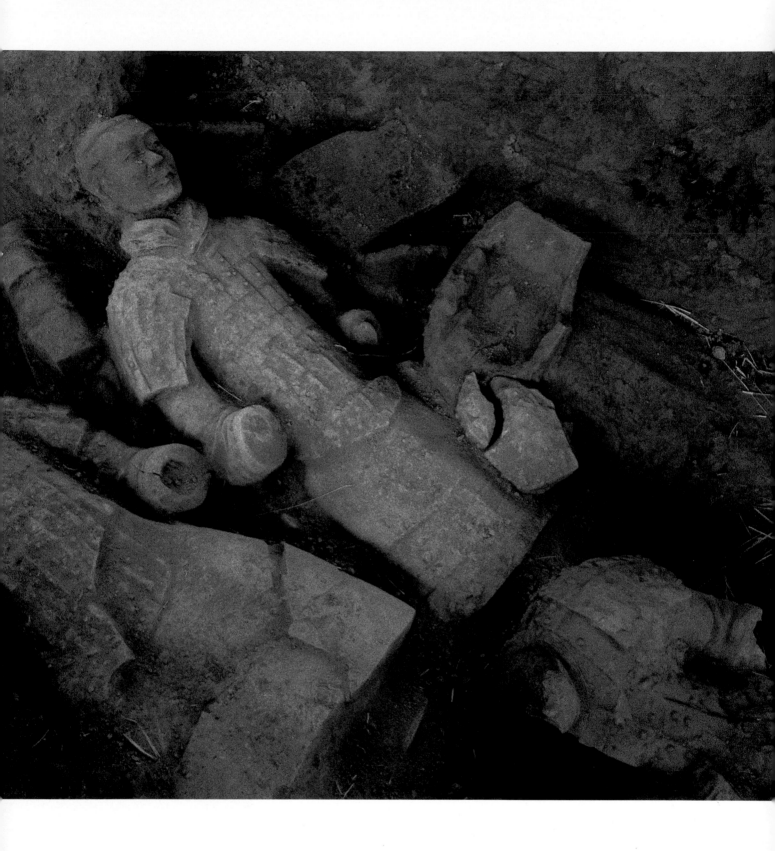

ACHIEVING FINE DETAIL

This photograph of a rhinoceros was one of the series of shots I made for the Metropolitan Museum of Art (New York City) for "The Great Bronze Age of China" exhibition's promotional material. Dating back to the third century B.C. and about 23 inches long, this artifact is representative of the type of object I was assigned to shoot. The room that served as my studio measured approximately 18 feet wide and 30 feet long. During two days of preproduction work, I asked my staff—six eager Chinese men and women—to cover the windows with heavy black cloth. Chinese electricians wired in my two Variac transformers, enabling me to reduce the power from 220 to 110 volts. I then blacked out the bathroom down the hall so that I could utilize it for film loading. Next, I unpacked all of my equipment and assembled it in one corner of the studio. Finally, after examining the collection of Chinese bronzes and organizing a shooting schedule, I was ready to begin

At this point, Mike Hearn, a curatorial consultant with the Metropolitan Museum of Art acting as my assistant, helped me arrange the lighting equipment and the set. We placed the rhinoceros on a brown earth-tone background and illuminated the artifact with an overhead Photogenic tungsten mini-spotlight with a large snoot. This established a strong shadow underneath the object. Hearn then positioned four mini-spotlights with small snoots around the object just below the level of the table so as not to introduce a second shadow. Each mini-spotlight was aimed at one of the rhinoceros' legs, defining its shape.

Next, we ran black-and-white Polaroid (Type 52, ISO 400) lighting tests, recorded the prime exposure of 2 sec. at f/22, and switched to Ektachrome 50 tungsten-balanced 4 x 5 film. This translated into a final exposure in color of 16 sec. at f/22. I shot three images at this setting. I then bracketed from 8 sec. to 24 sec. and exposed eight sheets.

This particular session was quite time-consuming. First, simply loading and unloading the huge amount of 4 x 5 film I shot required many trips down the hall to the blacked-out bathroom. Ordinarily, I shoot four still-life objects a day on an assignment. But because the museum had designated this imposing figure as a subject for a poster, my crew and I spent an entire day photographing the rhinoceros from different angles to capture its beautiful detail. Our efforts were, however, rewarded. The film looked great, and the museum's designers immediately started to lay it out for the catalog, poster, and postcard.

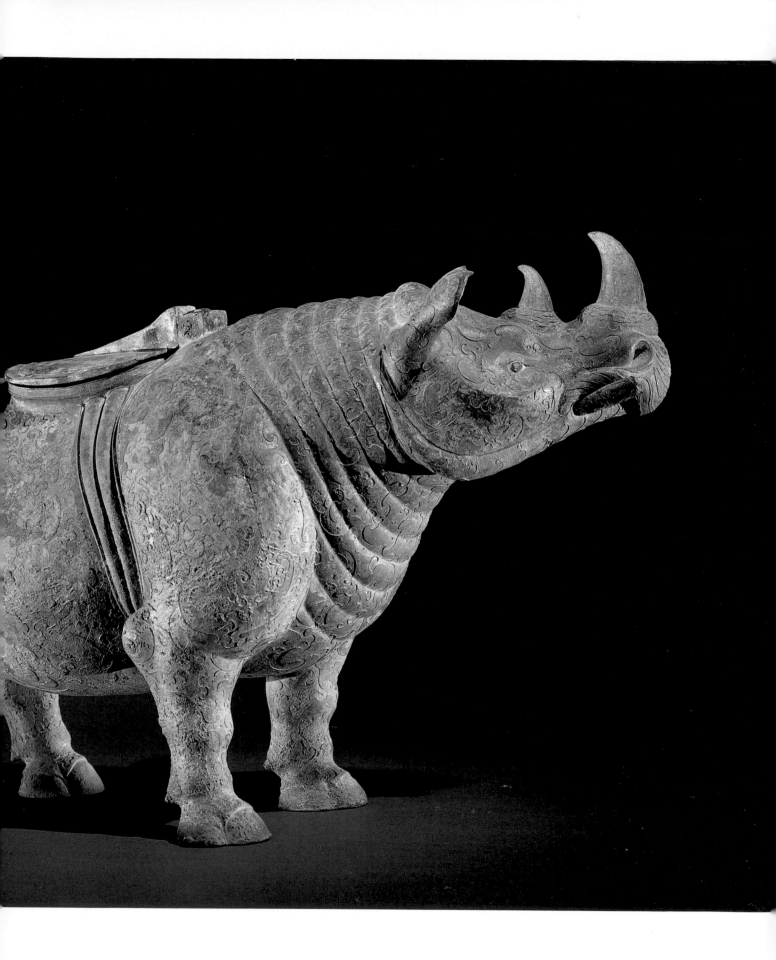

CAPTURING THE SUBJECT'S ESSENCE

For this assignment, book publisher Harry N. Abrams, Inc., asked me to capture the charm of a folk-art collection at the Museum of American Folk Art (New York City). Each image in the 12 x 16-inch, poster-size book would be displayed prominently. As a result, I had to think carefully about lighting and composition to fill the pages effectively. Editor Darlene Geis gave me some specific objectives and requirements as well. Most important, each photograph was to both spotlight the art object and establish a playful mood. This proved to be a challenge with some of the more "serious" pieces. But these late nineteenth- or early twentieth-century fish decoys made of wood, tin, and other metals, provided a natural subject for a lighthearted approach.

Creating the illusion of water for the background was my first—and the most obvious—choice. I decided to shoot the fish on black Plexiglas, which reflects other colors. Here, I placed a sheet of blue seamless directly behind the Plexiglas. My next task was to select the most interesting fish lures from the dozen the art handler showed me. I then wanted to make sure that the various colors and shapes related well to one another.

Next, to fully exploit the reflective properties of the Plexiglas, Frank Dzebella, my assistant, attached each of the fish to the Plexiglas with wax. I then viewed the composition through the groundglass and directed him to adjust each lure to maximize its reflection. Arranging and rearranging the fish was time-consuming. Finally pleased with the composition, I tightened down the camera stand and spent a considerable amount of time critically focusing my Sinar 4 x 5 view camera. Finding the optimum front-standard-tilt, rear-standard-tilt combination was painstaking, but essential.

Setting up the lighting equipment followed. My assistant and I lowered a large Chimera bank light equipped with a Speedotron strobe head adjusted to its full power of 2,400 watt-seconds from above the set. We positioned two large, silver reflector cards along both sides of the camera to fully illuminate the front of the decoys; this intensified the mirror image. Next, we set another Speedotron head at 2,400 watt-seconds, equipped it with an 8-inch reflector and a blue gel, and then bounced it off a sheet of blue seamless positioned directly behind the set. The angle of this light duplicated the camera angle, thereby providing the optimal reflection.

Balancing the effect of the Speedotron head bounced onto the seamless and the overhead bank light, however, proved to be a problem. I made many Polaroid tests before achieving the most effective lighting ratio. At that point, I switched to Ektachrome 64 daylight-balanced film and began shooting. I mounted a Schneider Symmar 210mm lens on my camera for maximum depth of field, additional coverage on the 4 x 5 film plane, and no vignetting. The final prime exposure was four pops at f/64. I then bracketed, shooting six sheets of film at 1/4-stop increments by varying the number of pops.

Both the publisher and the museum director felt that this particular photographic treatment captured the spirit of the folk-art collection. This photograph not only effectively juxtaposed the other pictures in the book, but also was chosen as the promotional image. Utilizing certain techniques from my advertising background resulted in a series of strong images—and a successful book.

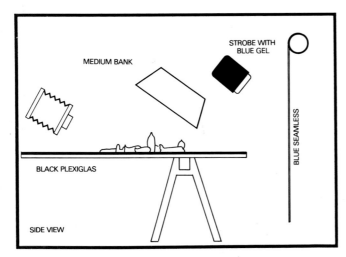

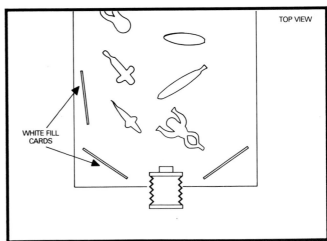

THE MIRROR IMAGE

A three-dimensional object like this fine ivory figurine often demands a special interpretation. Although the publisher of *Egyptian Treasures,* a poster-size book on Egyptian art in the collection of the Brooklyn Museum, assumed that I would photograph this tiny figurine as a simple frontal view, I realized that it was a natural subject for my "mirror trick." This combines a front view and a back view in a single exposure. By photographing the figure reflected in a mirror, I was able to capture its dimensionality, thereby enhancing its beauty.

This type of photograph requires the proper tools. The frontal-surface mirror, although expensive, is necessary; here, I used it to creatively embellish the presentation of a deserving figurine. Front-surface mirrors are known for their distortion-free clarity, which is essential for reflections. (Front-surface mirrors are commonly used in optical instruments, such as 35mm single-lens-reflex cameras.) These lightweight mirrors are made of Mylar and are available framed in sizes from 8 x 10 inches to 4 x 8 feet. But they scratch and collect dust easily, so I always store them in plastic until I am ready to use one. I selected a 16 x 20-inch frame for this shot, which was the perfect size for the small figurine.

Next, I lined the table with black flock, stood the mirror up, and placed the figurine on the set. I then positioned my Sinar 4 x 5 view camera. From a low camera angle, just below the reflective view in the mirror, the diminuitive figure's form looked dramatic, appearing larger than its actual 3 1/2-inch size. Rifling through my lenses, I decided to use a Schneider Repro-Claron 210mm lens. This macro lens is designed for reproduction ratios greater than 1:1. Behind the camera, I hung a full roll of black seamless to eliminate any outside reflections visible in the mirror through the camera's groundglass.

Focused and composed, I was now ready to set up the lights. When shooting sculptural objects, I prefer low-powered (200 watt-second) tungsten mini-spotlights: they enable me to effectively capture surface texture, sculptural modeling, and image environment. I placed mini-spotlights with small snoots on either side of the figurine to illuminate her form and to add specular highlights to her surface. The key light was a spotlight equipped with a small snoot and positioned on a boom about 12 inches above the figurine. This three-light pattern was sufficient for the small sculpture. Satisfied with the composition and the lighting pattern, I made several tests with black-and-white Polaroid 4 x 5 film (Type 52, ISO 400). Shooting with Ektachrome 50 tungsten-balanced film, I used a time exposure of 20 sec. at f/64 to achieve maximum depth of field from the figure to its reflection.

The resulting image proves that innovative approaches to shooting still-life objects can succeed when executed carefully and thoughtfully. Both the book publisher and the curator were delighted with this photograph of an exquisite ivory sculpture.

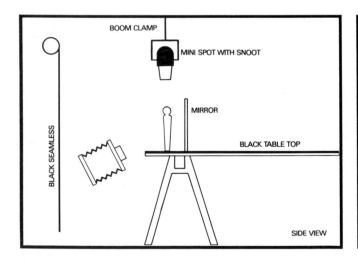

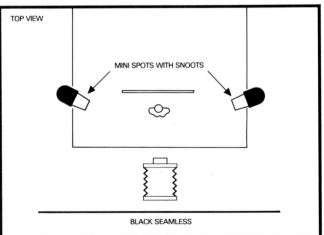

CREATING THE ILLUSION OF GRACEFUL MOTION

When the Metropolitan Museum of Art (New York City) was preparing a new wing devoted exclusively to the exhibition of Chinese artifacts, I was asked to create an image that would appear in poster form to accompany the opening. After shooting the simple three-quarter view of this magnificent female dancer, I was encouraged to experiment with a more interpretive treatment. This new concept called for creating a sense of movement in order to lend an element of life and style to this lovely object. The museum's curatorial department was willing to see if this unusual approach would yield a more compelling image than the original attempt had.

My assistant, Enid Mostrianni, and I began to tackle the task at hand by transporting the necessary equipment to the museum: hot lights, lightstands, booms, clamps, black seamless, diffusers, waxes (for attaching the object), my trusty Sinar 4 x 5 view camera, lenses, and film. Once in our makeshift studio, Mostrianni and I faced two challenges. First, we had to construct a small, rotating platform on which to safely place the dancer. We decided that the platform should be close to the floor and padded the floor beneath it with pillows. Also, because Mostrianni would be on her knees moving the sculpture stand by hand to create the desired blur effect, she would always be ready to support the object if it wobbled.

Our second challenge was to balance the exposure. This required extensive Polaroid experimentation with speed of movement and aperture in order to establish the best density. Maintaining the clarity of the silhouette while adding blur and motion was tricky. First, I carefully mounted the delicate object off center on the rotating sculpture stand. Then, guided by an art handler, my assistant and I found that tucking a small, wooden wedge under the sculpture's back foot balanced it perfectly. After illuminating all four sides of the dancer with low-powered mini-spotlights, we began making Polaroid tests of the multiple exposures against the black seamless backdrop. While the camera shutter was open, Mostrianni turned the sculpture by hand, creating the desired blur effect. Throughout the testing process, she kept careful notes and attached them to the Polaroids; this enabled us to re-create the most effective blur for the final exposure on Ektachrome 50 tungsten-balanced film.

By the time we were satisfied with the testing, she had recorded at least 40 different Polaroid tests. This process took two days. But it produced a dynamic, interpretive shot. Never before had the museum attempted such a radical approach with such a rare object. Although the original image was used for the poster, this photograph created a tremendous amount of excitement within the museum's walls.

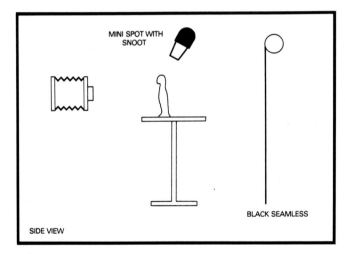

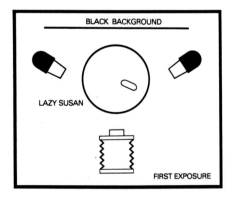

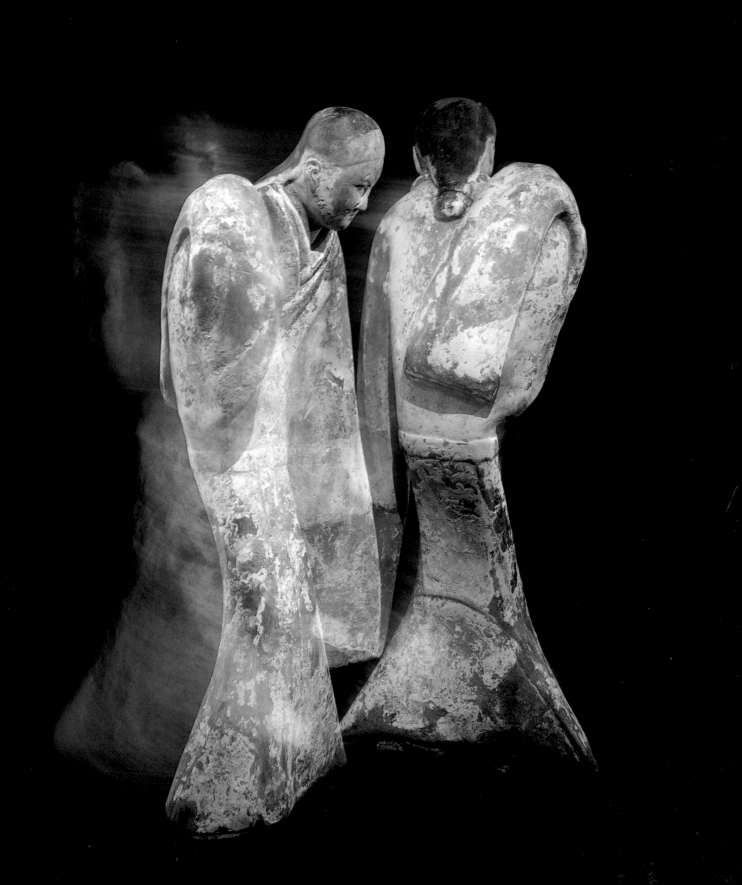

PRESENTING THE CLASSIC SPORTS CAR

For this photograph of a rare, handcrafted prototype of a Ferrari shot on location at the Museum of Modern Art (New York City), I was asked to provide an exciting view of this sports car. The museum intended to use the image on a poster and notecards, which would be sold in the gift shop. As such, emphasizing the car's classic design, unusual shape, and bright color was essential. The first take produced an excellent "record" shot of the car—complete with clarity, sparkle, and color saturation. But I found it too clinically clean and lacking atmosphere. I recommended an alternate composition shot outdoors in the museum's sculpture garden.

When the museum agreed, I proceeded. The car was rolled onto the garden's marble patio. Then, as I looked through my handheld Rollie SL-66 on which I had mounted a 50mm lens, I directed the museum crew to position the car underneath a huge, black steel sculpture by David Smith. The powerful image I had anticipated came together immediately. The overcast sky reflected a beautiful, broad highlight across the body of the car, defining the Ferrari's sleek shape. A 4 x 8-foot sheet of white foamcore propped up in front of the car reflected into the chrome grill and illuminated the bumper.

Ready to make some Polaroid tests, I set the camera at a low angle on a tripod. I focused on the front grill and then tipped the camera's front standard forward to achieve maximum depth of field. The lighting effect produced by the overcast sky was strikingly similar to that of a huge, overhead bank light. This kind of diffused lighting, with its absence of strong highlights or deep shadows, is perfectly balanced for optimum color saturation.

Next, with a perfect test Polaroid in hand, I exposed a roll of Ektachrome 64 daylight-balanced film for 1/2 sec. at f/22. I reloaded and realized that I needed to add black to the top of the image to accommodate the vertical poster format. To solve this problem, I skipped frames between exposures. As a result, each transparency would measure 2 1/4 x 4 1/2 inches, leaving the top half of it unexposed to register black. This area would blend with the top of the black sculpture. Although this technique made sense in theory, I waited anxiously for the test-roll results. Just as I had hoped, my plan worked perfectly. This shot remains one of my lead portfolio and promotional pieces.

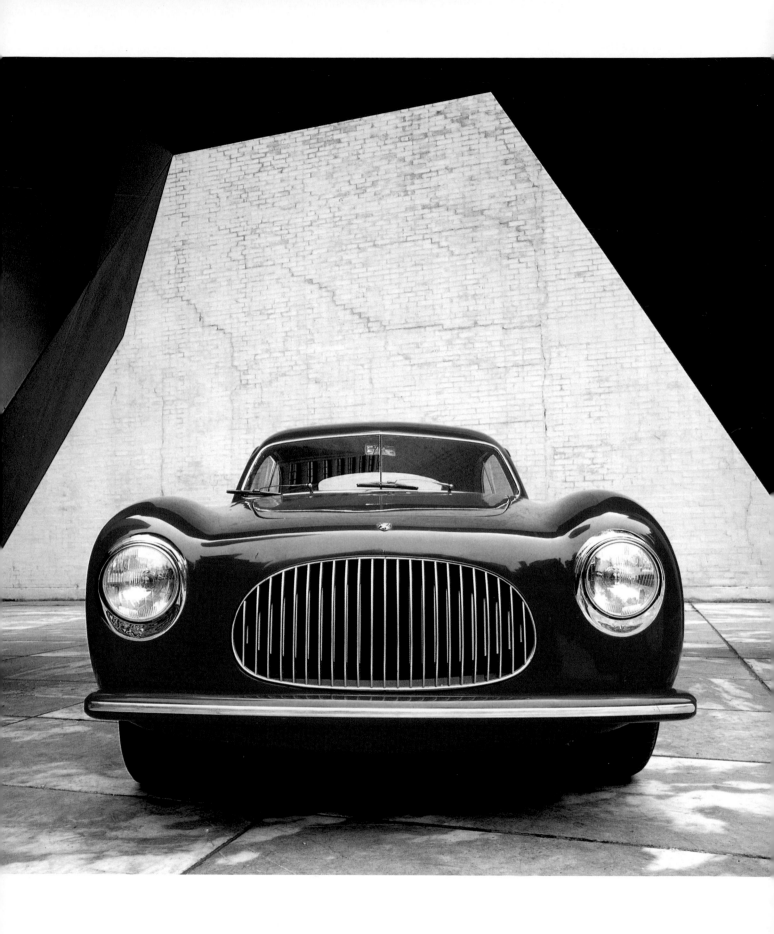

COMBINING ART AND NATURE

When I go on a trip or a vacation, I frequently combine professional and personal time. I was anxious to run color and sharpness tests after purchasing a Nikkor 200mm lens. So on a sunny autumn day, I packed my camera shoulder bag and organized a family picnic at the Storm King Art Center in upstate New York. This beautiful location is ideal for both a long-lens test and a family outing.

This impressive black, tubular sculpture by Alexander Liberman stood about 100 yards from our picnic table. As such, my perspective was perfect for checking the lens' sharpness at infinity. For testing purposes, I loaded my EL Nikkormat camera with Kodachrome 64 film and propped up the camera on a picnic table. This acted like a tripod and eliminated any camera movement, which would degrade my lens test. As I waited for the light to illuminate the sculpture to its best advantage, I began to think about the composition. By including the autumn trees in the foreground and the strip of grass, I effectively blended the sculpture and its natural environment.

Next, I shot an entire range of exposures from wide open at $f/2.8$ to fully stopped down at $f/22$. Each time I exposed, I popped up the mirror and used the self-timer to fire the shutter. I metered through the lens. The only problem involved waiting for people to walk by and view the sculpture. Luckily, about every five minutes another group would form, juxtaposing nicely with the artwork and completing the image. When I was satisfied with their position, I shot another frame.

Later, after editing the film and reviewing my exposure notes, I determined that the most effective image had been shot wide open. The lens' corner-to-corner sharpness at its widest opening was absolutely brilliant. Also, the lens clearly captured the detail of the black sculpture while it threw the foreground out of focus in this image. I was quite pleased with the fine results of this lens test. And, to add to my delight, I subsequently received a request from East/West Network, a magazine group, for images of the Hudson Valley region. This photograph was selected to run as a spread in *Vis-A-Vis* magazine.

Testing equipment can provide a stimulating opportunity for experimentation. It does not have to be regarded as a mundane technical exercise. By approaching this lens test creatively, I added a valuable image to my stock file. The sales of this photograph taken during a family picnic more than paid for the cost of the lens—and the lunch!

HOW TO COMBINE REAL LIFE WITH STILL LIFE

People lend a fresh dimension to still-life photographs that might otherwise be routine or dull. By introducing a model into a still-life composition, you can: add a sense of scale, as the shot of a baby with books included here shows; suggest a particular lifestyle, as the Grand Central Station photograph indicates; or help to convey a specific message, as the Volkswagen shot demonstrates. Conversely, adding a still-life element to a portrait can be an equally effective technique. For example, including the artist's painting of his wife in the double portrait of Will and Elana Barnet enabled me to capture the couple's special relationship.

Integrating still life and real life provides photographers with another creative tool to make innovative images when shooting clichéd situations. The goal is not to shock but to get the viewers' attention. If handled intelligently, the technique is an effective way to create memorable images. Your success depends in large part on the art of juxtaposition: the unexpected placement of objects and people next to each other. But you must immediately establish which element in the grouping is most important. For the editorial photograph of the man with a replica of the Empire State Building, I wanted to combine the individual with a familiar and easily recognizable New York landmark. Initially, I considered many locations and camera angles. Although the possibilities seemed vast at the outset, some preliminary scouting revealed that the cluttered environments did not project the quick read I required. The detailed model of the Empire State Building shown in the picture proved to be the ideal location-setting prop; it also added an element of surprise to the portrait. Besides propping, several other options are available to you. The lens can throw the appropriate element into sharp focus, thereby emphasizing it. This is a creative way to exploit depth of field. Another option is the skillful use of lighting, such as selective spotlighting. When combined with a blurring effect, as in the Grand Central Station picture, this type of illumination dramatizes the primary element.

For photographs that combine animate and inanimate subjects, I prefer to determine the lighting needed for the still-life object first, rather than trying to immediately decide on the overall lighting pattern. Handling the various elements individually is the best approach, but this kind of compartmentalization can be challenging. Begin by evaluating the lighting needs. Do you want the clarity of an electronic strobe or the definition of a flashbulb? Do you want to mix ambient light with flash to produce a bit of blur? Do you want the penetrating effect of a 1/4 sec.

tungsten time exposure? Experimenting with lighting techniques to determine the way they react to different film and lens combinations will enable you to expand your repertoire. In turn, this will free you to concentrate on creative decisions. Skilled still-life photographers will not find this task insurmountable.

Once you establish the lighting pattern for the still-life subject, your next concern is to arrange the lighting needed for the person. The presence of the model on the set leads to a certain amount of lighting-technique manipulation. For example, in the shot of the baby with the books, the still-life composition could have been a time exposure using tungsten light. However, with the addition of the restless infant, stopping action became the overriding consideration and required the use of a high-powered strobe. Sometimes, though, you can position and illuminate the model first and work with the inanimate object afterward. Once again, you must decide which element takes priority. Because photographs that combine people and objects are composed of multiple and often disparate elements, they require thinking on many levels.

If you are shooting a scene with models (amateur or professional), keep in mind that casting the proper talent for the photograph is a critical part of the preproduction phase. There are a few different approaches to organizing a casting call. Some photographers use production groups that take care of all of the details and then make recommendations, while others employ an independent casting stylist who works closely with them and the clients to assist in the model selection. I prefer this method because it allows me to be directly involved in the process.

Once the model choices are made, you must assess the technical demands of the project and establish an organized shooting schedule. The stylist assists by putting a *tentative hold* on the models; this gives you first rights to the models' time, as well as the option to reschedule without incurring additional charges. Then, after the bookings are confirmed, the stylist hires the models on an hourly basis with an added-

time option, so that the client will not have to pay a full day's rate for a shot that may take only three hours. If you intend to shoot on location, set up a rain date. Always have your assistants and production crew ready to begin when the models arrive on set. Remember: the models' fees start to add up the moment that they show up, either at your studio or on location. Here, time really *is* money.

The ability to interact effectively with people is paramount for shooting these photographs as well. It is important for you to establish rapport quickly: fees for models and studio time can easily add up. You may also want to ask models for their opinions on their positions, after explaining your objectives. The more you communicate with your models, the more comfortable they are on set. As a result, their cooperation is usually assured, and the shoot will proceed smoothly.

Finally, you may find that despite all of your preparation and preproduction work, a fully realized image will not come to mind until you are on the set. Serendipity can play a significant role. A random object left lying around can suddenly become the catalyst for the entire composition. The canvas in Will Barnet's studio, for example, sparked my idea to make it part of the portrait. When photographing very small objects, you might decide at the last minute to include a hand to establish size relationships. The introduction of a human element also makes what might otherwise be a sterile or dry image warm and appealing. Conversely, including an inanimate object in "people pictures" helps to provide a sense of place or reveal a personality.

Unquestionably, achieving creative effects by juxtaposing an inanimate object with a model is a challenge. The human element almost always adds the unexpected to an image. For these reasons alone, experimentation is essential. I find that combining still life and real life in a single photograph enables me to flex some new creative muscles. Also, I never think in terms of only set formulas for lighting or composition. Once you master the rules, you can break them.

A PERSONALITY REVEALED

Providing illustrations for editorial articles about art collectors usually poses a challenge: uniting the collector and the collection in a provocative image. This photograph was taken for *Connoisseur* magazine's story on the medieval-art collection of Ruth Blumka. During a preproduction meeting with editor Tom Hoving at Blumka Gallery, we selected dozens of unique pieces from her vast collection of medieval art. These ranged from a priceless papal signet ring to a miniature, hand-carved ivory shrine. My job was to convey this abundance in a shot that would be used as a center spread in the article. I also had to spotlight individual objects for point pictures for the text. As I began to organize the shooting schedule, I decided to concentrate on the still-life photograph first. This would enable me to establish a rapport with Blumka, in preparation for her portrait. This would appear on the article's opening spread.

Blumka was a dynamic woman who loved every piece in her collection. I wanted the portrait to convey her appreciation of medieval art, as well as how naturally she included these articles in her daily routine. I spent four days at the gallery shooting objects and planning the portrait shot. On the fifth day, Blumka was scheduled to sit between 11 A.M. and noon. This gave me only an hour to pull together the composition and to light the picture. As a result, John Bellacosa, my assistant, and I had to work fast. First, we placed the chair in front of the tapestry, which set the stage. Next, we moved the two thirteenth-century candelabras to frame the picture. As Blumka sat in the midst of this medieval-art grouping preparing to be photographed, I suggested that we light the candles. When Blumka proceeded, I knew I had come upon the perfect combination of art and art collector. Her presence enhanced the objects, and the objects revealed her personality. Next, Bellacosa set up my Hasselblad camera with a 50mm wide-angle lens on a tripod. As I established the point of view, Blumka fell into a natural pose holding a small figurine.

The lighting was accomplished with a single Dyna-Lite head set at 800 watt-seconds. Shooting the light through a translucent umbrella focused it on Blumka. This dramatized the wide-angle perspective and created the perfect mood. Positioning Blumka in the center of the picture minimized the distortion associated with wide-angle lenses and drew attention to the figurine she cradled. I ran a Polaroid (Type 665, ISO 80) test at f/11 for 1/4 sec. The time exposure allowed the candle flames to register clearly on film. Bellacosa loaded four filmbacks with Ektachrome 64 daylight-balanced film. Because I had spent some time getting to know Blumka earlier in the week, she was relaxed and cooperative. The entire sitting proceeded smoothly. We had about 20 minutes to experiment with different poses. I exposed eight rolls at f/11 and bracketed the shutter speed from 1/8 sec. to 1 full sec. The film was processed normal and looked fine. Throughout the range, a speed of 1/4 sec. produced the best balance.

For this assignment, I was able to combine a strong still-life composition with a revealing character study. Hoving, who had already committed prime space to this article, was pleased. The result was a dramatically illustrated story.

MAN AND MACHINE

The keen interest in the award-winning advertising created for Volkswagen during its heyday in the 1960s has led to a number of books showcasing the ads' unique style and photographs. I was asked to re-create one of the landmark pictures for the cover of *Is the Bug Dead?*, a softbound book published by Stewart, Tabori & Chang, Inc. No, this is not simply an upside-down image. And, while I was not able to actually turn over this now-vintage Volkswagen, I had to devise a way to project that illusion. My solution required a composite of two separate images. A week-long search finally turned up the perfect red Beetle. After arranging to have the car cleaned and polished, I was able to begin setting up the first shot.

I asked the nervous car dealer for permission to jack up one side of the Volkswagen at approximately a 45-degree angle. This position exposed enough of the undercarriage so that there was space to strip in the model's feet later. To further illustrate that the car was turned upside down with its underside exposed, I placed a Dyna-Lite strobe on the pavement on either side of it. These cast adequate light across the undercarriage and illuminated the tires.

As I do for many still-life compositions, especially those I shoot on location, I chose a Hasselblad camera, and an 80mm lens. I needed to make several Polaroid tests to balance the power of the Dyna-Lite strobes with the overall ambient light. I saved these Polaroids to use as visual guides later for juxtaposing the model. The final exposure turned out to be 1/8 sec. at *f*/11 on Ektachrome 64 daylight-balanced film. Also, as usual, I bracketed 1/2 stop in either direction and processed the film normal. The entire on-location shoot took a full day.

In comparison, the studio shot of the model was simple and straightforward. First, I posed him in front of white seamless paper. I then mounted a Dyna-Lite strobe with an umbrella on either side of the model, bouncing the light off the seamless. This produced a sharp silhouette line. Next, I positioned a white, 4 x 8-foot fill card in front of the model to reflect light onto him and to provide ample foreground definition.

At this point, I still had to resolve one other issue. This was the model's position, which was critical to the image's success. He had to look perfectly natural poised on top of the undercarriage. With the aid of the test Polaroids from the car shoot, I was able to ensure the proper placement of the model. I shot a Polaroid of the pose, cut it out, and simply inserted it over one of the Polaroids of the car. This enabled me to determine the correct position of the model's feet and body and eliminated the need for a great deal of experimentation.

The most efficient way to accomplish a composite picture is to keep careful records as well as all of your test Polaroids so that you can construct the image as you move from element to element. This photograph demonstrates that a composite picture can be effective; it does not have to look artificial or pieced together. I had a delightful time shooting this re-creation—probably as much fun as the Volkswagen people had when they conceptualized the advertisements.

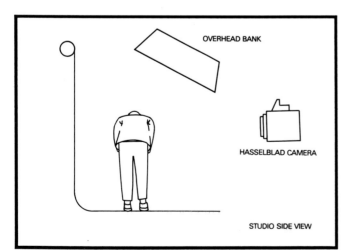

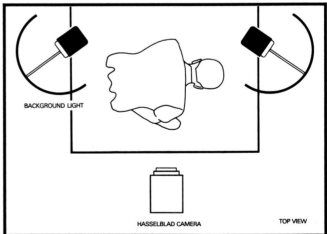

Is The Bug Dead? is about the friendly, reliable, cheap, durable, ubiquitous Volkswagen Beetle . . . the best-selling imported car ever. Here is the history of that little car and of Doyle Dane Bernbach's ad campaign for it, illustrated with more than 100 of DDB's greatest Volkswagen ads. Perfect for anyone who has ever owned a Beetle, chuckled at a VW ad, or who simply appreciates wit and style, *Is The Bug Dead?* will keep the Beetle's profile in view as it slowly vanishes from our highways.

IS THE BUG DEAD?

IS THE BUG DEAD ?

The Great Beetle Ad Campaign

Photograph by Seth Joel, courtesy Queensboro Motors

ISBN: 0-941434-24-9 / $8.95

AN INTRIGUING JUXTAPOSITION

Hired by *ArtNews* magazine to photograph painter Will Barnet in his New York City studio, I was asked to create an intimate environmental portrait. I arrived at Barnet's studio still thinking about how to do this shot when a stroke of luck resolved my dilemma: a recently completed painting of his wife, Elana, was mounted on an easel. Aware that the artist's best-known works depict women in harmony with their surroundings, I realized that the canvas was the perfect still-life prop for this photograph.

Always prepared for the unexpected, I brought an assistant and numerous cases filled with lighting equipment to the Barnets'. But, to my delight, the studio had an enormous skylight with a northern exposure. Of course, I decided to use the existing light to maintain the integrity of this classic artists' environment. My assistant and I set aside the lighting equipment and were then shown the entire studio. During the tour, I became acquainted with the Barnets. This is essential for any still-life photograph in which people are included.

As the four of us walked around, I was also scouting for the ideal spot to shoot from. Choosing a high vantage point—the mezzanine above the main floor—gave me the opportunity to use a 120mm lens on my Hasselblad camera. This lens would keep the composition tight in order to feature the juxtaposition of Barnet's wife in real life and still life. The resulting image revealed just as much about the artist (my subject) as it did about Elana (his subject). From my perspective, I was able to choreograph the couple. The rapport we established at the beginning of the shoot set the tone for a smooth session.

Seating the Barnets near the skylight washed them in a soft, northern light ideal for the black-and-white Tri-X film I used. I rated the film at ISO 400 and processed it normal in D-76. This combination yielded a balanced negative that printed well on a #2 normal-grade paper. After shooting six rolls of film, I thought that I had the shot, but I decided to move on to some closeups of the artist in various parts of the studio as backup anyway.

Photographers commonly walk into an on-location photo session completely cold. Unlike with studio still-life work, they often have no opportunity to preconceive a shot. Functioning creatively in an unpredictable situation requires a sharp eye and a flexible working style. An ability to respond quickly to the location and its unique quality triggers an imaginative photograph. Knowing that my first composition was by far the strongest, I felt comfortable presenting the material to *ArtNews*. The art director agreed with my judgment and ran the portrait as a full-page opening spread.

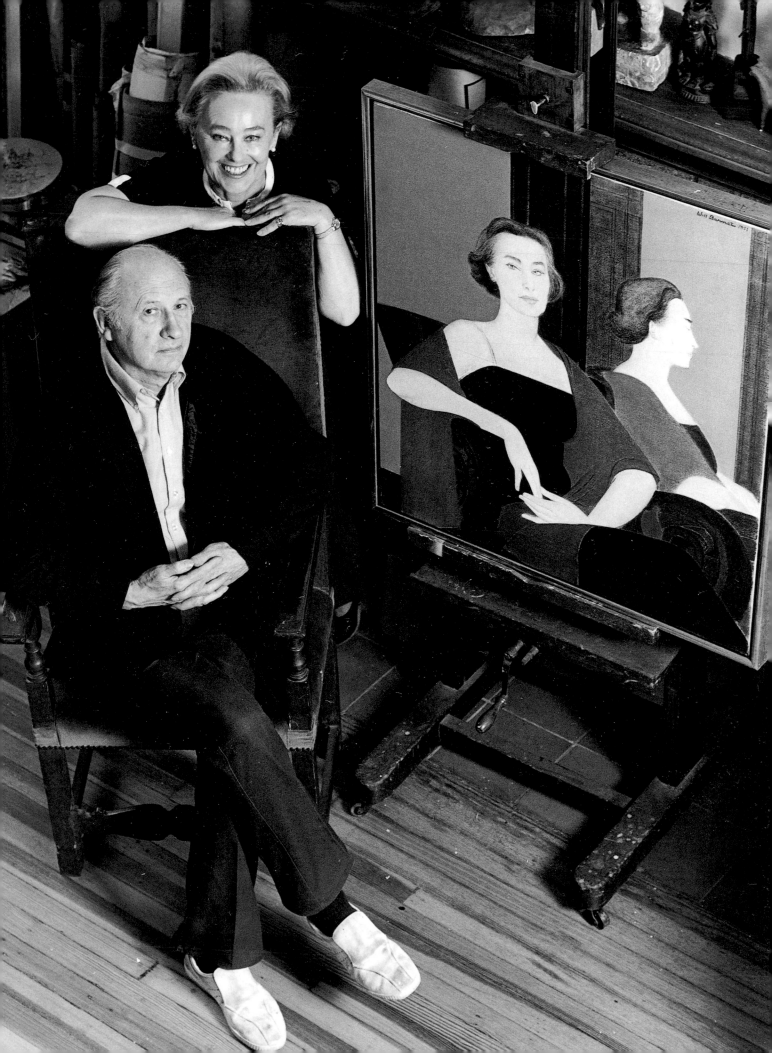

OVERCOMING TECHNICAL CHALLENGES

This photograph was taken for *Golf Illustrated* magazine for an article on the benefits of heat massage after a hard day of golf. During the preproduction meeting, art director Daryl Herman and I discussed communicating the idea of fingers moving along a back. I suggested having streaks of red light emanate from the masseur's fingertips to further emphasize that this was a heat massage. Herman was so enthusiastic about the concept that he volunteered to be the hand model. I chose a black male for the other model. Covering him with silver body paint enhanced the texture of his skin and provided a reflective surface to mirror the red finger lights. Then, by darkening the room completely, I made sure that no other light reflected off his body.

My first challenge was the lighting. While I did not want a traditional strobe picture in which one image blends into another and progressive motion is captured, I did want to create a sense of movement. I visualized the shoulders in sharp focus and the masseur's hands poised for action in soft focus. I decided on a combined tungsten-and-stroboscopic-lighting effect. This was accomplished with a Speedotron head with a medium spot grid firing at 1,200 watt-seconds. To achieve the red streaks, I attached small Christmas-type lights to Herman's fingers; these added elements of blur and motion, which increased the impact of the image enormously. Finally, to take advantage of the blue-seamless background, I placed an independent Speedotron strobe light low and behind the black model, angling it to produce a halo effect around the body, and fired it simultaneously with the key strobe light.

This experimental shot required me to make a number of test Polaroids. Both balancing the illumination of the strobes and determining the speed at which Herman should move his hands to maximize the red light were problematic. Too fast, and the red light barely registered; too slow, and the harnessed red lights washed out.

I selected my Hasselblad camera and a 120mm lens set at *f*/8, and Ektachrome 64 daylight-balanced film. This aperture provided shallow depth of field, highlighting the skin's texture. At my signal, the shutter was opened in the darkened studio, firing the key strobes and capturing a sharp image of the models' shoulders and fingers. With the shutter still open, my assistant then plugged in the red lights. Under my direction, Herman paused momentarily to let the eerie red glow burn in and, on cue, moved slowly over the back, not touching it. This glow reflected off the silver paint. Then, when Herman reached a predetermined spot on the model's back, I closed the shutter.

The photograph took much longer—and was far more difficult—to accomplish than I had anticipated. The harness that assistant Ken Maguire had designed for the lights and taped onto Herman's hands periodically loosened (because of the moisture on the other model's skin) and had to be retaped. Also, the red lights gave off so much heat that they began to burn Herman's fingertips and had to be continually removed, and the body model had to stand up and stretch his legs occasionally. Why go to all this trouble? This collaborative effort yielded an innovative, exciting image for the *Golf Illustrated* article.

BLUE PAPER

STROBE WITH REFLECTOR

HASSELBLAD CAMERA

STROBE WITH BLUE GEL

HARNESS OF CHRISTMAS LIGHTS UNDER FINGERS

SECOND EXPOSURE

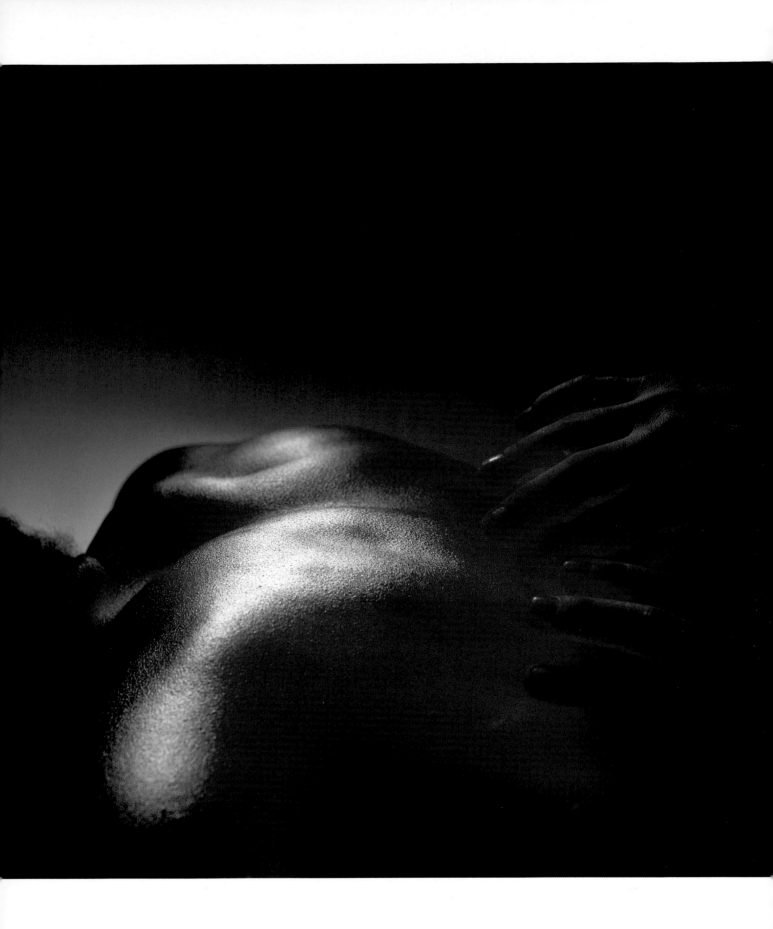

WORKING WITH YOUNG MODELS

When photographing infants, you will discover only one certainty: nothing is certain. To minimize this problem when shooting what is essentially a still life, you must prepare every possible element in advance. Bernice Pickett, a senior editor at *Mothers Today* magazine, hired me for a story on the intellectual development of babies. Her staff assembled all the props and cast the baby for the shot, in which the baby would serve as a bridging device between the past and the future. Because Pickett gave me a layout with the placement of the type indicated, my only tasks were to compose the picture and to establish a lighting pattern on the studio set before the infant came.

My first concern was the lighting. The books could be illuminated in a variety of ways, such as with tungsten lights that would require a slow shutter speed. The moving baby, however, would demand a high-powered strobe unit to freeze the action. So before the baby was scheduled to arrive on set, assistant Ken Maguire and I illuminated the framed pictures and books with an even spread of light, keeping in mind that a bouncing baby would soon be in the empty space. We hung a large Chimera bank light with a Speedotron head set at 2,400 watt-seconds over and just a little in front of the set. This provided even lighting for the area that would accommodate the text.

After thoroughly testing the lighting with Polaroid (Type 665) film, I established an exposure of 1/60 sec. at *f*/11 on Ektachrome 64 daylight-balanced film. I then concentrated solely on shooting to ensure capturing good body action. When the baby arrived, I placed the little boy in his designated spot. Soothing and cajoling him every step of the way, I proceeded to shoot. Speed was essential because of the baby's typically short (20-minute) attention span. There was no time for additional Polaroid tests. With the baby in mind, I decided to use my versatile Hasselblad camera with an 80mm lens: it is particularly well suited for shooting quickly. Because the baby was positioned on the same plane as the props, I had no problem holding focus. To capture the infant's peak moments, I needed to shoot a great deal of film. Naturally, this shot was not done in one take. The little boy was given breaks at least four times and then brought back on set for another round of shooting.

Because the editor was well organized and clear about the magazine's needs, this shoot went smoothly. But when photographing children, you may give in to the impulse to work quickly. Remember, however, that when using high-powered strobe units, you must pay attention to recycling time to prevent underexposure. During this shoot, my assistant kept his eye on the "ready" light and reminded me to slow down when I got carried away. I exposed the entire take at the same aperture and clip-tested a roll to verify density. I then had the balance of the film pushed 1/4 stop, which produced a large group of prime frames. I did a preliminary edit before turning over the film because of the number of acceptable shots. I find that thoughtful follow-throughs are just as important as on-set technique and help to ensure repeat business.

A CANDID STILL LIFE

My background in still-life photography landed me this challenging, 12-image advertising campaign for *Reader's Digest* magazine. Once a month for a year, a different photograph would appear on the back page of the business section of the *New York Times*. Art director Vic Cardia recognized that my lighting and problem-solving techniques could be successfully applied to this assignment. During lengthy pre-production meetings, Cardia and I discussed casting and location requirements. Each location had to be familiar to Manhattan business executives, and the models and extras were carefully chosen. They had to appear to fit in with the environment in order to make the posed shots seem authentic and credible.

My challenge was to balance the importance of the models with the need to create a striking image that conveyed a sense of place. I decided that using the 35mm format for the series would give the photographs the editorial flavor the client wanted. I then chose black-and-white Tri-X film (ISO 400): I knew that this high-speed film would most effectively capture the desired spontaneous feel, as well as the grainy imagery associated with reportage.

My still-life background was especially valuable when I photographed this image in New York City's Grand Central Station. Once I looked around the entire area, I determined the exact spot from which I could make an interesting visual composition. The image had to be both aesthetically pleasing and able to depict the true flavor of a busy, congested area. The clock and the information booth are highly recognizable and would establish the location. Using actual commuters in a blurred fashion as extras would eliminate the problem of securing model releases for this particular shot. This technique would also provide the perfect background canvas for the two principal models.

My first assistant, Chris Boas, and I set up the equipment in the mezzanine approximately 50 yards away from and above the models. Using a Nikon F2 camera with a Polaroid back custom-made by Marty Forscher and a Nikkor 180mm lens on a tripod, I shot numerous test Polaroids at different time settings. Boas carefully recorded the exposure information for each Polaroid so that we would be able to determine the optimum time exposure for the commuter blur. A Hawk radio slave enabled Steven Lopez, my second assistant, to stand on the main floor to the right of the models, just out of camera range, and aim a handheld Norman 200B strobe directly at them. After instructing the models to maintain their poses, I shot slowly and deliberately to capture the ideal juxtaposition of the blurred commuters with the stationary models. Here, the key characters would be separated from the people in the background. Between the test Polaroids and actual shooting time, we devoted two hours to this shot. Still, because I was working so slowly, I shot only two rolls of film.

Candid still-life pictures are not simply a case of point and shoot. The ability to visualize and compose an image under all conditions is critical to successful execution of unusual assignments like this one. Being thoroughly familiar with equipment and film capabilities is also important: if you are in control of the technical requirements of an assignment, you can concentrate on the creative aspects while on location. The 35mm format and the Tri-X film I chose for this campaign proved to be ideal. It adapted easily and beautifully to every situation, even the cavernous interior of Grand Central Station.

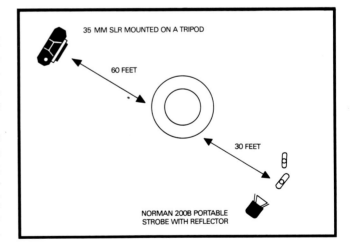

35 MM SLR MOUNTED ON A TRIPOD

60 FEET

30 FEET

NORMAN 200B PORTABLE
STROBE WITH REFLECTOR

HOW TO SUCCEED IN A CHALLENGING FIELD

Photographers may be called still-life specialists, but within this description lies a variety of advertising and editorial assignments. This section shows the rather eclectic range of markets professional photographers must be able to handle with style and technical proficiency in order to succeed in this demanding field. Still-life photography is required for product packaging, catalogs, audiovisual presentations, print advertising, and editorial work. The drawbacks of specialization can be diminished when photographers demonstrate an ability to function creatively in all of these areas. This broadens the still-life photographers' choice of markets as well as cushions the impact of inevitable slow times.

Cultivating catalog clients helps you both build the steady business necessary to pay studio overhead and establish good working relationships with stylists, assistants, processing labs, and other industry vendors. When I am assigned to shoot a merchandise catalog, I allocate a section of my studio to the merchandise and packing cartons. As the merchandise arrives, one of my assistants checks its condition and indicates this on the client's item list. Next, my assistant groups the various pieces of merchandise on a worktable according to the layout specifications. As soon as order is re-established in the studio, I make two shooting sets to take full advantage of the shooting time. As the client's deadline nears, an efficient and cooperative production crew is essential. Although catalog photography may seem mundane, exhausting, and highly repetitious, it can also be a challenge: you have to shoot an attractive, appealing image of each piece of merchandise. Every page in a catalog is visually important. For example, I approached the brass collection shown in this section as I would precious jewelry. I wanted to get the most out of its special reflective qualities and make it look expensive. Catalog work requires both an understanding of the client's needs and the ability to present the merchandise in its best light in order to boost sales.

With editorial work, on the other hand, you must be able to sell ideas. To properly generate these ideas, you may have to do some research. I begin an editorial shoot by reading the accompanying text (whenever available). Next, I review back issues of the publication to gain design insight. For the ergonomics photograph shown here, I was given the task of conceptualizing an appropriate illustration on set. During the preproduction meeting with the magazine's art director, he stressed that

I should produce a dramatic opening spread. He supplied me with the alabaster figure, a double-page layout board marked for type space and point-picture placement, and his direct telephone number at the magazine to call in case I had any questions. In addition, editorial work allows more creative freedom. You can concentrate completely on aesthetics rather than glorification of a product. So while you cannot neglect composition, color harmony, lighting, or technique, you can take more risks. Editorial assignments may not pay as well as commercial work, but they are almost always stimulating. Also, the added exposure of a credit line increases your name recognition, and the tearsheets provide useful promotional tools.

The chance to develop concepts and explore new creative territory can get you through even the most demanding or dull assignments. A routine audiovisual slide show provided me with fascinating picture opportunities for the shots utilizing abstract shapes and Old Master light shown in this section. Once again, I evaluated each object individually and carefully even though I knew that they constituted only a small part of the presentation.

Fortunately, strong still-life images are an important element in package design. This opens up a huge number of markets from spark plugs to candelabras. Shooting an image for a package or box is an intriguing challenge: I think of it as a miniature billboard. The image must have a powerful, poster-like quality so that the package will jump off the shelf. Your objective is for your client's product, not the competitor's, to appeal to the customer. Also, because clients have a need for package longevity, they are usually willing to invest more to achieve lasting quality.

The consumer-product advertising market can be described as the still-life photographer's final frontier. For example, an advertising agency calls in photographers' books because it plans to produce a big-budget, 12-image national print campaign, complete with regional outdoor usage. As the agency's creative team reviews the photographers' portfolios for artistic style (illustrated in editorial shots) and experience (illustrated in catalog shots), the still-life photographers' books will look impressive—and, perhaps, ideal for the assignment.

Clearly, opportunities for professional still-life photographers do exist in markets that are crowded, competitive, cantankerous, and continually changing. Careful, long-range business planning is needed for you to successfully explore these creative opportunities. Keep in mind that just as each assignment builds on the preceding one, so do your sense of style, professional standards, networking, and business direction. Be flexible, and pursue assignments in the different photography markets available to you. This will help to broaden your photographic reputation. To facilitate client referral and repeat business, increase your visibility with regularly scheduled promotional mailers. Use the telephone, too: name recognition is paramount.

Although this marketing approach to photographic success is logical and straightforward, it requires continual maintenance. I have seen talented photographers come and go because they failed to keep up with trends. You can avoid this serious problem by being an active participant in the editorial market. Although some photographers dismiss these areas, I think that the time has come to dispel these antiquated notions. This type of work satisfies every creative urge and gives free reign to artistic expression.

SHOOTING A PACKAGE ILLUSTRATION

Photography for product packaging has specific and challenging parameters. The images must be seductive, but at the same time, literal and graphically simple in order to accommodate all the necessary printed information. Also, props must be kept to a minimum so that they do not compete with or misrepresent the product. This image was part of a series of package illustrations for the May Merchandising Corporation. I was presented with 50 products to photograph individually. In each illustration, creative director Susan Lieber wanted to feature the product on the front of the box and to have the props and the background wrap around the right side of the box. This meant that each box had to be carefully scaled down to fit on a 4 × 5 format.

The company also wanted the photographs to project a sense of traditional elegance. During a pre-production meeting, stylist Carla Capalbo, Lieber, and I discussed various approaches to the assignment. I suggested that we commission an artist to paint an abstract background to be used as the stage for the entire product line. Lieber liked the idea of adding a unique element. Next, the three of us agreed that by choosing from among the same group of props, we would establish a consistent look for the series. Assistant Ken Maguire, Capalbo, and I then ran lighting and style tests until we came up with the look Lieber wanted.

This image of a silver candelabra is typical of the photographs I made for this assignment. The candles were cut short to give the appearance of recent use. The starfruit and napkin added color and texture to the composition but did not detract from the candelabra. The illumination of the backdrop was low and moody. To achieve the lighting effect, I carefully feathered low-powered, Photogenic mini-spotlights on the candelabra in order to balance bright spots and shadows. Then, by arranging six of these 200-watt, 3200K tungsten spotlights, I was able to highlight all the reflective elements. I exposed the shot for 8 sec. at $f/22$ on Ektachrome 50 tungsten-balanced film; the long exposure was necessary to allow the candle flames to register clearly. The use of multiple, direct light sources to produce a single shadow required me to place each lamp carefully. I had to examine the lighting effect on the 4 × 5 groundglass while my assistant moved the mini-spotlights to the proper positions.

Not yet satisfied with the lighting pattern, I decided to add a background lamp. This enabled me to vary the tonality of the painted backdrop, as well as to create shadows that enhanced both the product and the backdrop. Ready to begin shooting, I chose a Sinar 4 x 5 view camera and a Schneider Symmar 210mm lens. The large format provided an excellent viewing area, which is ideal when type and gutter placement are critical to the composition.

Whatever the merchandise—food, toys, houseware, and jewelry—photography usually plays a major role in the way these products are marketed. Here, the decision to echo the classic elegance of the houseware in the subtle, hand-painted backdrop was a great success. The client received only compliments and positive feedback from its stores and buyers. The company felt that the packaging helped to increase sales, which was, of course, its primary objective. As a result, the client selected me as its leading photographer.

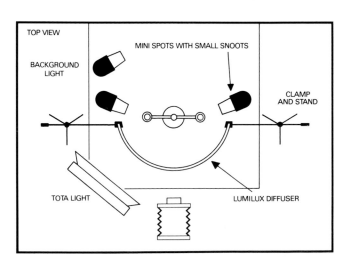

THE MULTIPLE-OBJECT CATALOG SHOT

Shooting an assortment of products for a decorative-accessories catalog poses many challenges. One of the difficulties involves combining a number of different items in an interesting composition without obscuring any individual piece. This photograph of brass merchandise proved to be just such a demanding assignment. When Harrison Services, Inc., a design firm, commissioned me to photograph a Christmas catalog for a midwestern department store, I found this shot to be among the most complicated. I faced the problem of reflections—the inevitable result of light bouncing off the brass and creating a confusing image.

My first task was to frame the empty set from above through my Sinar 8 × 10 view camera with a Schneider Symmar 240mm lens. My assistant, Ken Maguire, began to polish the objects while art director Helen Serfling arranged the set. As I evaluated the picture area on the groundglass, she placed the brass merchandise on the set to conform to the layout. Serfling's rationale was simple: the most popular merchandise should be displayed prominently up front, and the remaining items should be thoughtfully arranged to create a strong composition.

Two hours later, Serfling and I were pleased with the design. I then tackled the lighting. My main concern here was to control the reflections: too many reflections are distracting and burn up on film while carefully balanced reflections make brass appear richer and more attractive. To provide the necessary diffused illumination, I immediately chose a large, 2,400 watt-second strobe bank light and hung it over the set. Next, I augmented this overall lighting with white 8 x 10 fill cards. These served to highlight dark corners and to fill in "dead" areas. Balancing the lighting for this shot was another time-consuming activity. I had to shoot numerous 8 × 10 Polaroid (Type 809, ISO 80) tests in order to determine appropriate highlights and interesting contrasts. I spent approximately two hours experimenting before I established a lighting pattern that satisfied me.

The prime exposure on Ektachrome 64 daylight-balanced film was eight pops at $f/45$. I exposed six sheets at 1/4-stop increases and processed the entire take normal. The sheet I ultimately chose for reproduction had the maximum highlight brightness.

Shooting this merchandise catalog benefited me in several ways. I was given the opportunity to hone my technique. Also, the rapport the art director and I developed by working so closely together on these demanding catalog shots was the foundation for a solid working relationship. Perhaps most important, the strength of these catalog images led to numerous other assignments. Perseverance pays off.

THE WONDERS OF PHOTOMACROGRAPHY

Providing fresh perspectives on commonplace products or ordinary objects is an ongoing challenge in advertising photography. *Photomacrography*, the enlargement of exceedingly small objects, offers still-life photographers fascinating opportunity to devise innovative approaches. This technique should be applied to appropriate subjects, to help emphasize a message or visual point, not to exploit its shock value or to do something different.

In preparation for assignments necessitating photomacrography, I made this test shot of Dexatrim, an appetite suppressant in capsule form. I wanted to discover and learn how to solve any potential problems associated with this technique. I also hoped to create a dynamic portfolio piece that would showcase my skills. The capsules provided a natural subject for this photograph. To make the image dramatic and to reinforce Dexatrim's time-release effectiveness, I included a stopwatch. It not only perfectly expressed the idea of stopping time, but also added a strong graphic element to the composition.

At this point, I began to deal with the technical demands of the photograph. First, I experimented with various lenses on my Sinar 4 × 5 view camera in order to select the best one for the magnification and depth needed. I chose a Schneider Repro-Claron 135mm *f*/8 lens, which is noted for its superb sharpness and short bellows draw at high magnification. I positioned the camera directly above the approximate set area required for the composition and roughly focused. I soon discovered that I also needed a bellows extension of about 16 inches.

Because I was shooting at such an extreme magnification, I achieved critical sharpness by moving the entire camera toward or away from the subject—rather than by turning the rear-standard focusing knob. The capsules were on a set made from three 8 x 10 sheets of nonreflective plate glass, stacked with a 1-inch space in between them. This created a three-dimensional stage for the composition. Assistant Ken Maguire placed a stopwatch on the middle shelf; besides its literal purpose, it served to establish the parameters of the picture. At this point, I lowered the view camera into sharp focus. Maguire then arranged the capsules on the top shelf, using blobs of wax to hold them in place. I gave him direction as I checked the composition on the groundglass with a Schneider loupe. The last step was to place the time-capsule beads on both the middle and bottom shelves. This slow, labor-intensive process, which involved moving each pinhead-size bead with a fine tweezer, created depth.

The lighting pattern was deliberately simple: any additional shadows or highlights would be exaggerated and distracting at this magnification. I used a single Speedotron strobe head mounted on a small bank light set at 2,400 watt-seconds. Positioning the light as close as possible to the capsules produced full highlight detail and rich color saturation. A small, white fill card on the dark side of the set opened the shadows gently and balanced the lighting. Finally, I double-checked the focus and made some color Polaroid (Type 59, ISO 80) tests. I then exposed six sheets of Ektachrome 64 daylight-balanced film for 1/60 sec. at *f*/16. After evaluating the film processed normal, I had the rest pushed in 1/4-stop increments. The prime sheet was pushed 1/2 stop.

Moving the camera in tiny increments for photomacrography is quite tedious and calls for patience. This image required two days of painstaking experimentation before I was satisfied with the results. Although this technique is not easy, the results are well worth the effort.

CREATING A MULTIPLE EXPOSURE

Problem-solving plays a large part in photographic work. From the beginning of any illustrated project, the photographer is involved at the conceptual level. For this editorial assignment on ergonomics for *Digital Review*, a technical magazine that caters to the computer industry, I met with art director Bill Jensen several times and asked to read the text that would accompany the image. He then gave me two items to help me produce a compelling shot: an alabaster sculpture and a layout indicating the gutter and type placement on a double-page spread. I was left alone with my imagination to create the image.

After testing different lighting and lens techniques, I realized that in order to achieve the effect I wanted, I would have to break the photographic elements into three separate exposures on a single sheet of Ektachrome 64 daylight-balanced film. I decided to use a Schneider Super Angulon 90mm lens on a Sinar 4 × 5 view camera to produce a dramatic, wide-angle perspective. For the first exposure, I wanted to illuminate the alabaster sculpture from below to enhance its warm color and texture. So I constructed a stage for the sculpture out of a 1/2-inch-thick sheet of milky Plexiglas, behind which hung a sheet of black seamless. Next, I positioned the key light, a Lowel 1,000-watt, tungsten spotlight balanced for 3200K—to enhance the warm alabaster on daylight-balanced film—directly underneath the Plexiglas. The illumination from this light made the sculpture appear to glow and its surface appear rounded. I made some Polaroid (Type 52, ISO 400) film and exposed six sheets of color film at *f*/32 for 4 sec.; I marked the holders and put them aside.

The second shot produced a striking background. First, I opened the shutter and lens wide, and revealed a projection screen by rolling up the black seamless. I then front-projected my stock 35mm photograph of lake water shot with a blue gel. By angling Kodak Carousel projection slightly higher than the view camera, the image appeared behind the figure's head. With the lens stopped down to *f*/16, I checked the exposure and background positioning with Polaroid tests. I then exposed the same six sheets for 12 sec. The third exposure provided a sharp pool of light to draw attention to the figure's fingertips. I created the highlight by placing a pinpoint snoot over an 800 watt-second Dyna-Lite head set at full power and aimed 2 feet from the fingertips. Stopping the lens back down to *f*/32, I exposed the six frames at 10 pops in order to thoroughly burn in the highlight. The image for the double-page spread was now complete: I chose the four frames pushed 1/2 stop during processing.

The small insert pictures on the layout were 35mm shots that I made in the studio later. For these point pictures, I established a lighting pattern that would allow me to move around the sculpture freely with a 35mm camera, recording it at different angles on Kodachrome 25. By so doing, I provided the art director with a number of variations to choose from. Although I spent two full days and three boxes of Polaroid film balancing all the elements to create this technical shot, it was both a professional and critical success. The client was thrilled with the image, which was singled out by *Photo-Graphics* as one of the best editorial trade spreads of the year.

ERGONOMICS, *the science of man-machine interaction has evolved from a buzzword into a serious computer buying consideration. More than ever, personal computers are designed with users in mind and research in Fortune 500 companies has proven that ergonomically designed personal computers increase productivity and decrease the health risks associated with computer use.*

DEC is a recognized leader in ergonomics reseach and its personal computers are its ergonomics showpieces. In this special ergonomics section, <u>Digital Review</u> explores "the science of comfort" and how it has been applied to personal computers in the office environment.

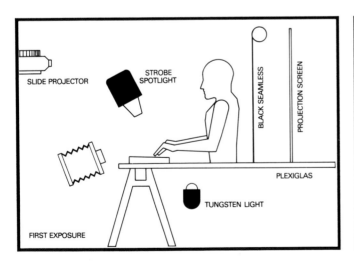

SLIDE PROJECTOR

STROBE SPOTLIGHT

BLACK SEAMLESS

PROJECTION SCREEN

PLEXIGLAS

TUNGSTEN LIGHT

FIRST EXPOSURE

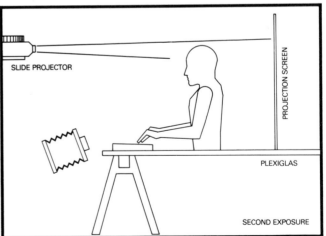

SLIDE PROJECTOR

PROJECTION SCREEN

PLEXIGLAS

SECOND EXPOSURE

A CLASSIC ABSTRACTION

This photograph was one of many taken for an audiovisual slide show produced by The Fashion Group, an international trade association. Through the presentation, the client had hoped to provide its audience with an overview of design elements in vogue at the time. The association wanted images with interpretive flair. To accomplish this, I decided to use existing light and available elements of composition whenever possible.

The Fashion Group directed me to shoot at a number of locations. This shot was taken at D.F. Sanders and Company, Inc., a New York City–based specialty shop devoted to products with sophisticated designs. Steven Lopez, my assistant, and I arrived with a Norman 200B flash outfit and a shoulder bag filled with two Nikon cameras and a large selection of lenses. I had also packed color film with all different temperatures and film speeds to be able to handle any spontaneous idea that the location might prompt. As I looked around the store, I was intrigued by a group of small, black flower arrangers displayed on a table by the front window. The repeating pattern they formed fascinated me. I realized that I had found my subject.

Because the grouping was part of the front-window display, my first concern was the lighting. At midafternoon, the light coming through the window was diffused. I moved a few objects that shadowed the composition and then began to think about the creative treatment. I did not want to rearrange the flower pots: they fit together neatly and fulfilled my wish for design purity perfectly. Although the lighting was beautiful, I knew that it would lack impact on film. I loaded the camera with Ektachrome 50 tungsten film balanced for 3200K because it would react to the daylight (rated 5500K) and produce a cool, midnight-blue tone over the entire image. This would immediately increase the color contrast and create a stronger visual impact. Satisfied with the concept, I mounted a Nikon F2 with a Nikkor 35mm perspective-correcting lens on a Husky tripod. I composed a tight picture at a high angle that exploited the reflection of diffused light on the inside of the flowerpots. The manual stop-down characteristic of the 35mm perspective-correcting lens offers an advantage: it makes viewing depth of field easy. Next, I shifted the front element up and down until I was content with the composition. I then metered through the lens and bracketed, starting at f/16 for 1/2 sec.

While the preparation for and actual photographing of this shot seem quite simple on the surface, what made the image successful was my willingness to break rules. Shooting tungsten film with a daylight source goes against conventional wisdom. But I knew that this would produce cool tonal values, creating the futuristic effect I wanted. The Fashion Group was also delighted with my interpretation. Abstract images can elevate an otherwise ordinary slide show into an exciting, trend-setting event. Breaking photographic rules is worthwhile: experimentation not only builds a repertoire of innovative techniques, but also eliminates boredom and extends creative vistas.

AN EXQUISITE UNION OF LIGHT AND DESIGN

This photograph was another image that I shot for The Fashion Group's slide show. One of the places listed on the client's shooting script was Ross, Kloda & Williams, an avant-garde shop specializing in one-of-a-kind furnishings. Located in New York City's East Village, the store has a particularly intriguing aesthetic. I was immediately inspired to capture the existing atmosphere in a creative way.

In order to enhance the abstract elements of each location I photographed for this series, I made a technical decision at the beginning of the assignment to use only available light. Here, I took full advantage of my choice by shooting Fujichrome 100 daylight-balanced color film under the shop's existing tungsten light. This combination of film and illumination resulted in a warm orange tone, which is commonly referred to as Old Master light. Although this technique contradicts photographic convention, I find it to be one of the most successful ways to enhance a product's appearance. The mellow effect of Old Master light is especially appropriate for decorative objects: the illumination produces a sense of warmth and simplicity. As a result, I thought that it would be ideal for this atmospheric image of a vase and a candleholder.

Having decided on the film for this photograph, I turned my attention to composing the image. I thought the existing composition was perfect because it was stripped of all extraneous elements. As such, I felt that its uncomplicated nature complemented the beautiful quality of the Old Master light. I did, however, like the shape created by the tungsten lamp and deliberately kept it in the frame. This light also accentuated the curve of the vase and highlighted the vase's texture. The long, slender candleholder helped to provide scale, making it the prominent subject. Against the canvas-like background, the painterly light created by the daylight-balanced film reinforced the image's spare but exquisite design.

With my Nikon F2 and a Nikkor 85mm f/1.8 lens mounted on a tripod, I took a through-the-lens meter reading. The exposure was f/8 for 1/15 sec. I then bracketed the exposure and moved on. Once again, The Fashion Group was more than satisfied with the final photograph.

Experimenting with different lighting techniques—particularly Old Master light—requires patience and precision. With too little light, the image becomes obscure. With too much light, the effect loses delicate tonal value. Be prepared to shoot an entire pack of test Polaroids just to get the light balance correct. However, if there is not enough time for Polaroid tests, shooting a tight selection of bracketed exposures is critical. Having a strong collection of experimental Old Master subjects on film provides a useful resource when this effect is needed for an actual assignment.

UTILIZING A DRAMATIC
WIDE-ANGLE PERSPECTIVE

My father, Yale Joel, and I collaborated on this *Smithsonian* magazine assignment to shoot the interior of the Pierpont Morgan Library in New York City for an article on the library's rare-book collection. Two shots would be run as full-page bleeds without any text at the beginning of the article. As the introductory images, it was critical that they capture the environment in a compelling fashion. Still-life photographers always strive to establish a unique perspective, but their subjects do not always present an opportunity to utilize adventurous techniques. After I gave some thought to this assignment, however, I realized that the location would allow an extremely wide-angle treatment.

To achieve this, I decided to photograph the library with a seldom-used, customized Speed Graphic XL 2 1/4 x 3 1/4 camera. Marty Forscher, a master of camera repairs and equipment modification, designed an interchangeable back that would enable me to shoot in the 4 x 5 format. Then, by adding a Schneider Super Angulon 47mm lens, I was able to create an extreme wide-angle perspective that vignetted the corners of the compositions. This created a dramatic keyhole effect.

My next concern was the lighting balance. Wanting to maintain the warm, incandescent light of the rooms in which the rare-book collection was housed, I chose to shoot Ektachrome 50 tungsten-balanced film. With the addition of a Lowel 1,000 watt-second spotlight, I was able to illuminate the foreground and add depth to the image. At this point, I tested the lighting balance with black-and-white Polaroid (Type 52) film. I stopped down to *f*/32 to obtain maximum depth of field and exposed for 8 sec. This was the basic exposure. Next, I bracketed a series of six sheets at 1/4-stop increments by altering the length of each exposure. I then processed all the film normal.

The entire shoot required only one full day on location. Because propping was not necessary, my only requirement was to provide *Smithsonian* with the dramatic, detailed images that the magazine desired. Here, the radical wide-angle perspective produced by the modified camera enhanced the opulence of this period room with its lush, turn-of-the-century decor. The magazine was delighted with the resulting images. The story ran as planned with this photograph as one of the full-page lead pictures.

INDEX

ABOUT THE AUTHOR

Seth Joel started in photography at an early age. His father, Yale Joel, an award-winning photographer on the original staff of *Life* magazine, put a Rollei camera in Seth's hands at the age of six. In his teens, Joel apprenticed himself to noted art photographer Lee Boltin and was soon considered an expert in the field of photographing precious objects. In 1979 the Metropolitan Museum of Art in New York City offered him the opportunity to photograph the objects for "The Great Bronze Age of China" exhibit, while they were on location in China. He has since produced books, posters, and exhibition catalogs for that museum as well as for New York City's Museum of Modern Art, The Bishop Museum in Hawaii, New York City's Brooklyn Museum and Fashion Institute of Technology, and The Armand Hammer Foundation in Los Angeles.

Maintaining a studio in New York City since 1979, Seth Joel has solved difficult lighting problems and brought imaginative dimensions to inanimate objects for advertising clients and editorial publications, including such magazines as *Smithsonian, Connoisseur,* and *Art News*, and Time/Life Books. He lives in a renovated Jersey City brownstone with his wife and two small children.